HIDDEN
HISTORY
of
NEW HAVEN

Robert Hubbard & Kathleen Hubbard

THE
History
PRESS

Published by The History Press
Charleston, SC
www.historypress.com

First published 2019

Manufactured in the United States

ISBN 9781467140829

Library of Congress Control Number: 2018966262

CONTENTS

PREFACE

The authors' association with New Haven began early. We both participated in grammar school trips to Yale University's Peabody Museum of Natural History. Like most kids, we were impressed by its Great Hall of Dinosaurs with its brontosaurus skeleton and its 110-foot-long, 16-foot-high mural, *The Age of Reptiles*, which was created by artist Rudolph F. Zallinger between 1943 and 1947.

Author Kathleen Hubbard recalls that years later, she had school fundraisers and applied for grant money to hire buses for 120 students so they could experience the same wonder at seeing these extinct, majestic creatures. When Kathleen decided to further her education, she chose New Haven's Southern Connecticut State University. In 2002, she received a sixth-year degree in educational foundations from the school.

In the early 1990s, Robert was hired as a full-time professor at Albertus Magnus College as well as an adjunct faculty member at South Central Community College (shortly afterward renamed Gateway). Highlights of his time in New Haven included: serving as a volunteer at the biennial Special Olympics World Games, which were held in New Haven in 1995; waiting in line for four hours on Temple Street to audition for the 2007 movie *Indiana Jones and the Kingdom of the Crystal Skull* (only to discover the director was looking for dog owners who could play football); and teaching thousands of incredibly enthusiastic New Haven–area students at Albertus Magnus and Gateway. He retired from Albertus Magnus and Gateway after twenty-two years at each school.

While writing this book, these authors interviewed many people who recalled fond memories of life in New Haven. Both authors traveled down memory lane themselves and also learned new things about this city while writing this book. We hope you, the reader, enjoy our book and learn some hidden history.

ACKNOWLEDGEMENTS

Many thanks to Harold Andrew Batty Jr., Susan Batty Santoski and Teresa Santoski, grandson, granddaughter and great-granddaughter, respectively, of the 1921 Rialto Theater Fire hero Reginald Batty. We are also indebted to Donald E. Sockman Jr., Gene Sockman and the family of U.S. Navy flier James Shapiro for information on the air crash of 1953.

A sincere thank-you to Frank W. Myjak for information on the 1957 Franklin Street fire and to Nancy Kelly for information about her father, Norman H. Kelly, who was one of the three survivors of the Tweed–New Haven Airport disaster of 1971.

Our gratitude goes to Thomas Benincas Jr. of New England Photo for allowing us to use some of his incredible photographs.

We appreciate the information that Donna and Robert Maturo provided on Gustave and Anna Anderson. We thank the following people for the information they furnished on East Rock Park: Dr. Copeland MacClintock, retired researcher for Yale Peabody Museum of Natural History's Division of Invertebrate Paleontology, and Thomas Parlapiano, the Peabody Museum's manager of school and teacher engagement.

Many thanks to Sarah L. Woodford, director of the Vincent Library at the Saint Thomas More Chapel at Yale University, for her assistance. Thom Peters, a member of the history faculty and the school archivist at the Hopkins School, was most helpful in providing us information and photographs on the history of his school. Thanks to Roberta Vine for information on her father, businessman and entrepreneur Ruby Vine.

We would also like to thank the following individuals for their assistance: Milton Cohen, Dr. Norman Davis, Blanchard Granville, Christine Hansen and Michele Massa.

We were pleased to be able to work again with Michael G. Kinsella at The History Press. Every book needs a good editor, and Mike is the best. We were happy that Abigail Fleming was available to copyedit this book. Last year, she did a wonderful job on our *Hidden History of Middlesex County*.

Thanks to Max Spurr at the Wallingford (Connecticut) Public Library and Andrea I. Faling at History Nebraska (Nebraska State Historical Society). We would like to thank reference librarian Allison Botelho at the New Haven Free Public Library, as well as the staff of the following wonderful institutions: the New Haven Museum and its Pardee-Morris House, the Knights of Columbus Museum, the Yale University Art Gallery, the Yale Peabody Museum of Natural History, the Beinecke Rare Book & Manuscript Library, the Yale Collection of Musical Instruments, the Hamden (Connecticut) Public Library and the Shubert Theater.

Introduction

Three of New Haven's most prominent natural features are New Haven Harbor—which is fed from the north by the Quinnipiac and Mill Rivers—and two fault block ridges, West Rock and East Rock. These ridges are composed of large expanses of bedrock that were broken up into blocks about 200 million years ago during the Triassic and Jurassic periods. The trap rock is a dark-colored and fine-grained rock. The area that New Haven occupies today was covered about 22,000 years ago by about one-half mile of ice from the last of the four glaciers of the Pleistocene epoch. The southern edge of the glacier ran across the northern shore of Long Island.

Up until the 1600s, the land on which the city of New Haven sits was the home of the Quinnipiac tribe of Native Americans. They built villages around the harbor and were proficient at fishing, hunting and farming.

The story of the English settlement of New Haven began when about 250 immigrants sailed out of England for a better life; this included the Puritans, who wanted freedom from religious persecution and its English class structure. After reaching Massachusetts Bay Colony in 1637, the English Puritans decided to start a community based upon biblical teachings and eventually found a "new harbor" along Long Island Sound. Transactions took place between the settlers and Momauguin, who was the sachem (leader) of the Quinnipiac people. A signed agreement for the purchased land included protecting them from the fierce Pequot and Mohawk tribes and a small amount of trade goods.

The first time the name *New Haven* was mentioned was in their General Court meeting notes on September 1, 1640: "This toune now named Newhaven." The court required all men (age sixteen to sixty) to enroll and be trained in the militia for any hostile Indian invasion. In 1639, seventy men signed a Fundamental Agreement that they would be governed not as an English government but as a Bible commonwealth so only church members could hold public office or vote. Charles II's royal charter joined New Haven and Hartford together in 1662, much to the dismay of the former's original settlers; the charter granted "freemen" additional freedoms and liberties, including self-government. In 1701, the legislature decided that these two settlements would be co-capitals. New Haven was the co-state capital of Connecticut along with Hartford from 1703 to 1875, and each October, the General Assembly would meet in New Haven.

The City of New Haven has several major claims to fame: foremost, it is one of the great historic American cities that was founded in colonial times—you can explore many spots in the city where its past is still visible today. There are many well-established places of learning located here—including its world-famous Ivy League school, Yale University, and the Hopkins School, which was founded in 1660. Composed of people from many diverse cultures, the city is sometimes known as the "Cultural Capital of Connecticut."

the signing of the treaty that ended the ...
first mayor was Roger Sherman, who since moving to New ...
had been a state auditor, a superior court judge, and a key member of ...
Continental Congress (1774–81, 1784). He would serve as mayor of New
Haven from 1784 until his death in 1793. However, Sherman's main claim
to fame was that only he signed all four of the United States' founding
documents: the Articles of Association, the Declaration of Independence,
... Confederation and the Constitution of the United States.

EARLY NEW HAVEN

The Treaty of Hartford, which ended the Pequot War, was signed in 1638. The conflict had pitted the English colonists and their Mohegan and Narragansett allies against the Pequot tribe. It is said that the land now occupied by New Haven was first recognized by the English colonists as potential land for settlement when they were pursuing Pequot warriors from New London to what is now Fairfield County.

The English settlement of New Haven began in 1638, when forty-one-year-old Oxford-educated minister John Davenport and forty-seven-year-old London merchant Theophilus Eaton brought a group of recent immigrants from Boston to the location that was then called Quinnipiac. The party was composed mostly of wealthy English merchants and their families. When they arrived in New Haven, they set to work on building homes similar to those they were accustomed to back home—in many cases, large two-story houses.

The New Haven settlement never had serious conflicts with the local Native Americans. The latter were few in number and welcomed the English after years of oppression by the Pequots and the Mohawks.

Reverend Davenport and businessman Eaton carefully crafted a government based upon scripture. Within months of New Haven's founding, the center of the village was divided into nine equal-sized parcels. It was the first of many planned communities in America. Today, that land makes up the New Haven Green. In 1640, when the settlement's name was changed to New Haven, it had a population of about 460 men, women and children.

In 1639, Eaton was elected the first governor of the New Haven Colony and served in that position until his death eighteen years later.

New Haven was incorporated as a city in 1784, which was one year after the signing of the treaty that ended the American Revolutionary War. Its first mayor was Roger Sherman, who since moving to New Haven in 1761 had been a state senator, a superior court judge and a key member of the Continental Congress (1774–81, 1784). He would serve as mayor of New Haven from 1784 until his death in 1793. However, Sherman's main claim to fame was that only he signed all four of the United States' founding documents: the Articles of Association, the Declaration of Independence, the Articles of Confederation and the Constitution of the United States.

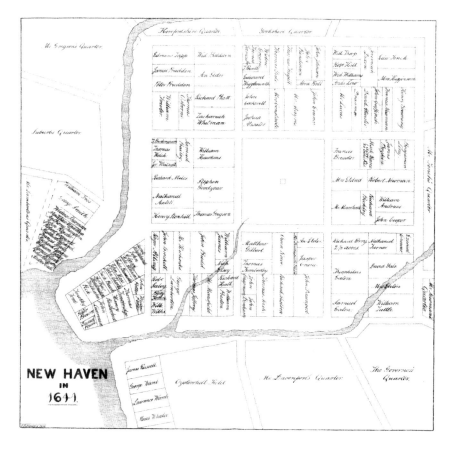

Map of New Haven in 1641. *From the 1902 edition of Edward E. Atwater's* History of the Colony of New Haven to Its Absorption into Connecticut.

New Haven originally encompassed Wallingford (which included today's Cheshire and Meriden and broke away in 1670), Branford (which included North Branford and split off in 1685), part of Woodbridge (which included Bethany and separated in 1784), East Haven (until 1785), Hamden (until 1786), North Haven (until 1786), part of Orange (which included West Haven and broke away in 1822).

Throughout the nineteenth and the early twentieth centuries, New Haven's population boomed. Immigrants from dozens of countries were especially attracted by the growing number of factory jobs. In 1800, the city had only about 4,000 people; by 1900, that number had risen to well over 100,000. The city's population on the eve of the Civil War was about 40,000. Approximately 3,000 of these were foreign-born, with most from Ireland, along with some Catholic, Lutheran and Jewish immigrants from Germany.

In 2010, the city's population was still only about 130,000, although the greater New Haven area was estimated to be home to about 860,000 people.

EARLY HOMES OF NEW HAVEN

The homes of the seventeenth-century New Haven settlers were similar in construction to the houses their owners were familiar with back in England. Most were composed of two rooms with a large central chimney. Settlers who were richer or had large families might have a second full story with an entrance hall and a stairway inside the front door. Because temperature ranges throughout the year differed between England and southern New England, New Haven home owners and house builders learned to protect the buildings' exteriors with wooden clapboards.

The average homeowner burned about fifteen cords of wood (about two thousand cubic feet) each year. To conserve heat, home builders used fewer windows and constructed lower ceilings. The exteriors and interiors of most homes of 1600s New Haven were unpainted.

GHOST SHIP

In 1630, Captain Nathaniel Turner left England, sailed to Massachusetts and later settled in New Haven Colony. His home stood at the corner of

Church and Wall Streets, near the site of the today's New Haven County Courthouse. Between 1640 and 1646, Turner commanded the military forces of the colony. In January 1647, he and three other merchants left for London in what may have been, up to that point, the largest ship ever to sail from New Haven. Later designated the "great shippe," it was filled with samples of almost every trade good New Haven had to offer. The mission's purpose was to establish trade with England.

According to an account by Puritan minister and writer Cotton Mather (1663–1728), the vessel was put under the command of a Captain Lamberton, who had misgivings about the seaworthiness of the ship. Still, it was loaded with tons of goods and carried passengers who were eager to travel back to their home country.

At the ship's launch, New Haven Harbor was frozen over, and a three-mile-long channel had to be cut in the ice before the ship could reach open water. New Haven minister and co-founder of the New Haven Colony John Davenport is reported to have prayed: "If it be thy pleasure to bury these our friends in the bottom of the sea, they are thine, save them."

Months later, travelers from England reported that this ship had never arrived at its destination. Then, in June 1648, eighteen months after its departure, an afternoon thunderstorm hit New Haven. In the storm's aftermath, about an hour before sunset, the lost ship was seen approaching the harbor. But it was not in the water—it was on a cloud.

Hundreds of people ashore watched as the ship slowly made its way toward them. It was the same vessel—the hull, the mast and the riggings were unmistakable. Its sails were spread wide as if filled with a great wind. But it was sailing against the wind.

Some witnesses said they saw Captain Lamberton on deck pointing his sword toward the sea. Suddenly, the crowd saw the masts being blown apart, and the ship slowly vanished. The sighting had lasted between thirty minutes and an hour. Many people believed it was a sign that the ship had been lost at sea. Indeed, the vessel was never heard from again.

Cotton Mather published his *Magnalia Christi Americana* in 1702, fifty-four years after the event. He quoted a letter from New Haven pastor James Pierpont that related the details of the story. Mather concluded with the statement: "Reader, there being yet living so many credible gentlemen, that were eye-witnesses of this wonderful thing, I venture to publish it for a thing as undoubted as 'tis wonderful.'"

The story of what would be called the "Ghost Ship" would go down as one of the most famous tales of the supernatural in American history.

SKELETONS UNDER THE GREEN

After the Ghost Ship, New Haven would experience another unusual occurrence 364 years later.

A large oak tree on the New Haven Green near the corner of College and Chapel Streets was toppled by Hurricane Sandy's eighty-mile-per-hour winds, and a passerby noticed human bones intertwined with the tree's roots. Coincidentally, the remains were found the day before Halloween in 2012.

A skull, spinal column and rib cage were sent to the Connecticut state medical examiner for evaluation. Those studying the find included Yale anthropologist Gary Aronsen and Connecticut state archaeologist Nicholas Bellatoni. Further excavation revealed what appeared to be bones from two adults and two children under age ten. A marker next to the tree stated that it had been planted in 1909 to mark the 100th anniversary of President Abraham Lincoln's birth.

It is a recognized fact that the New Haven Green land behind Center Church was the main city graveyard from the mid-1600s to 1797. In 1821, the headstones were moved to Grove Street Cemetery, and most of the human remains were left behind. However, it is a rare occurrence for any of these graves to be disturbed.

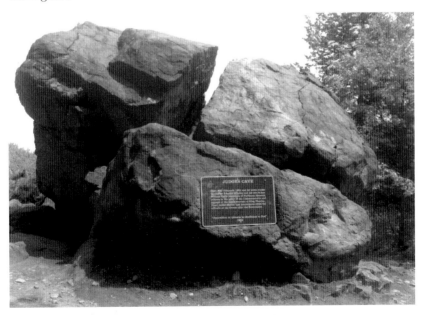

Judges who signed the death warrant of England's King Charles I hid in this New Haven rock formation in 1661. *Authors' collection.*

JUDGES CAVE

In 1649, Charles I became the only English monarch ever executed by his people. Three of the fifty-nine members of Parliament who signed his death warrant were later hunted in the American colonies by Charles's successor, Charles II, who restored the English monarchy in 1660. Charles II ordered the trio to be hanged, drawn and quartered.

The three judges—John Dixwell, Edward Whalley and Whalley's son-in-law William Goffe—first sought refuge in Boston, but later Whalley and Goffe traveled to New Haven. Starting on May 15, 1661, they hid out in a rock formation on a mountain in western New Haven. Still well preserved, and today known as Judges Cave, it is in the center of West Rock Ridge State Park.

The three men were never caught by the English authorities. Whalley and Goffe are believed to have died in the late 1670s, while Dixwell passed away in 1689 at about age eighty-two. Their memory is kept alive today by the three major New Haven streets that were named after them: Whalley Avenue, Goffe Street and Dixwell Avenue.

CENTER CHURCH CRYPT

One of the best-preserved reminders of American colonial life is found in the basement of the Center Church on New Haven's town green. When the structure was built between 1812 and 1814, it was positioned over part of the town burial ground. Today, visitors can climb down a flight of steps into a chamber that has 137 gravestones; they mark the last resting places of

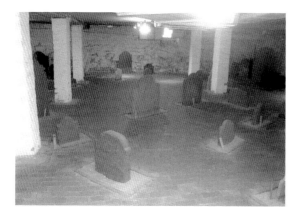

The Center Church's crypt, containing 137 grave markers, is one of the best-preserved colonial burial grounds in the country. *Authors' collection.*

Benedict Arnold's first wife, Margaret Arnold, and President Rutherford B. Hayes's grandmother and aunt, among others. The crypt's oldest marker is that of Sarah Rutherford Trowbridge, who died in 1687.

The crypt had a dirt floor until 1879, when it was covered with concrete. According to the Center Church's website, in 1985, experts determined that the concrete floor was "capping moisture in the ground, causing the stones to act as wicks," thus destroying some of them. In 1990, a new floor of uncemented bricks was installed, which allowed the moisture to be released.

JAMES HILLHOUSE

Hillhouse is a well-known name in New Haven. Hillhouse High School is the city's oldest public high school (founded in 1859), and Hillhouse Avenue is a major street. They were named after James Hillhouse, who served Connecticut in both the U.S. House of Representatives (1791–96) and the U.S. Senate (1796–1810). Born in 1754, Hillhouse moved to New Haven at age seven, and he attended Hopkins Grammar School and Yale College. At Yale, he was friends with Nathan Hale and frequently corresponded with Hale after they both graduated in 1773. Remaining in New Haven as a lawyer, Hillhouse was captain of the Second Company of the Governor's Foot Guard when New Haven was invaded by the British in 1779. His bravery in action led to him being elected to the Connecticut General Assembly.

Hillhouse was one of Congress's earliest opponents of slavery. In 1799, he was a member of the Senate committee charged with working to end the slave trade, and after the Louisiana Purchase four years later, he led the move to outlaw slavery in the new lands. He stated: "I consider slavery as a serious evil, and wish to check it wherever I have authority."

According to historian Don Fehrenbacher, Hillhouse's amendments were "the strongest antislavery restriction imposed on any portion of the Deep South between 1735 and 1865." In 2011, the Amistad Committee and the Gilder Lehrman Center for the Study of Slavery, Resistance and Abolition held a ceremony at Hillhouse's gravesite to honor his role in opposing slavery.

In addition to his many government obligations, Hillhouse was treasurer of Yale College for fifty years (1782–1832) and was instrumental in planting so many elm trees in New Haven that it acquired the name "The Elm City." He died in New Haven on December 29, 1832, and is buried in Grove Street Cemetery, which he helped to establish.

WHY NEW HAVEN OWNS LAND
ON THE EAST SIDE OF THE HARBOR

From the early 1600s to the American Revolution, East Haven was part of New Haven. The Town of East Haven broke away in 1785 when the State of Connecticut approved its incorporation as a separate town. For the next century, the Quinnipiac River was the border between the two municipalities. During this time, East Haven had the responsibility for the operation and maintenance of the four bridges that connected it with New Haven. In 1881, East Haven's expenditures associated with the repair and maintenance of these bridges resulted in an $180,000 debt.

To pay off this debt, the East Haven Board of Selectmen and the residents of the town voted to sell the western third of East Haven's land to the City of New Haven. This property comprised three neighborhoods, Fair Haven, Granniss Corners and Morris Cove, and was home to about 70 percent of East Haven's residents.

Even after the transfer of land, the three former East Haven areas maintained a degree of independence. Between 1911 and 1959, the Fairmont Association provided police and firefighter services in the eastern harbor shore independent of the City of New Haven.

LONG WHARF

Long Wharf is an area of the city alongside New Haven Harbor. Up until the 1950s, it was the location of the longest wharf in the United States. Beginning at the intersection of Water Street and Union Avenue, it stretched out into the harbor for a length of three-quarters of a mile. The wharf was destroyed when construction began on Interstate Routes 95 and 91.

In the nineteenth century and the beginning of the twentieth century, New Haven Harbor was primarily used for the transport of coal, recreational activities and the processing of oysters. In fact, it was considered the oyster capital of the United States in the 1800s, with New Haven companies distributing their product throughout the country. Much of that came to an end as the Mill and Quinnipiac Rivers became polluted.

Even in 1939, New Haven Harbor oysters were considered so valuable that four men from Milford and Bridgeport were charged that year with raiding privately owned seed oyster beds in the harbor. Connecticut state

police tracked them to Long Island, where they were arrested. The men were fined and given suspended jail sentences.

At the end of the twentieth century, the fate of oysters in the harbor wasn't very bright. Folk music artist Tom Callinan, who by an act of the Connecticut General Assembly was designated Connecticut's official state troubadour, recorded a song titled "You Can't Eat the Oysters in New Haven Harbor."

WARS AND MONUMENTS

N ew Haven's residents have served their country in every war. Here are the stories of some of those conflicts and a few of these remarkable people.

THE AMERICAN REVOLUTION

Like many cities in the late 1700s British colonies, New Haven was split between residents who were loyal to the king of England and those who yearned for independence from the dictates of Parliament. A few key players in the struggle known as the American Revolutionary War are examined here: included are a general who died fighting British invaders and a general who switched sides to join the British; a New Haven man who gave his life for the new nation when he was merely twenty-one years old; and another, who, after serving in the Patriot forces, lent his artistic talents in documenting the Revolution and its leaders.

THE POWDERHOUSE INCIDENT

Benedict Arnold, who was later to play such an important role in the American Revolution, had a business on the south side of Chapel Street between

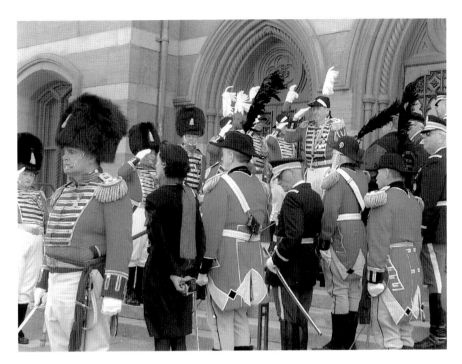

On the New Haven City Hall steps, the Second Company of the Governor's Foot Guard reenacts the Powderhouse Incident in 2018. *Authors' collection.*

College and Temple Streets. His home—no longer in existence—was on Water Street near the shipyard. Since moving to New Haven in 1762, he had worked as a druggist, a bookseller and a West Indies merchant.

In April 1775, word reached New Haven that British forces had fired upon American militia in Lexington, Massachusetts. The New Haven city government voted to remain neutral. However, about forty members of the local militia—the Second Company of the Governor's Foot Guard—and its leader, thirty-four-year-old Captain Benedict Arnold, had other ideas. On April 22, they marched across the New Haven Green to the town offices, and Arnold demanded the keys to the powderhouse, the repository for New Haven's supply of gunpowder and musket balls. The town selectmen were told that unless they handed over the keys in five minutes, Arnold would order the powderhouse broken into and the supplies taken. They immediately handed over the keys. Reverend Jonathan Edwards, a supporter of the Patriot cause, gave his blessings to Arnold's men, and they proceeded to march to Massachusetts. The following month, Arnold and

Ethan Allen and their men distinguished themselves by capturing New York's Fort Ticonderoga from the British.

Each year, the Second Company of the Governor's Foot Guard reenacts the handing over of the keys on the steps of the New Haven City Hall. It is a rare moment, as it is the only major celebration in the state that portrays Benedict Arnold as a Patriot, which indeed he was—until he committed treason a few years later.

GENERAL DAVID WOOSTER

Born on March 13, 1711 (March 2, 1710, on the Julian calendar), David Wooster graduated from Yale College in 1738. While in his late twenties, he became a captain in the new Connecticut coast guard and, in 1745, married Marie Clapp, the daughter of the fifth president of Yale. In 1745, Wooster fought in the King George's War Siege of Louisbourg in French Canada, and from 1755 to 1761, he served in the French and Indian War, rising to the rank of colonel. After the war, he settled in New Haven as a businessman and was appointed collector of customs for the Port of New Haven.

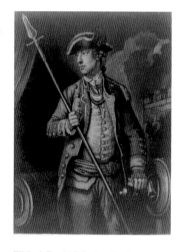

Titled *David Wooster, Esq'r.— commander in chief of the Provincial Army against Quebec*, this image of New Haven resident David Wooster was published in 1776. *Courtesy Library of Congress, Prints and Photographs Division.*

At the beginning of the American Revolution, Wooster was a general in the Connecticut militia. In 1775, he helped plan the successful capture of Fort Ticonderoga by American forces under Benedict Arnold and Ethan Allen. Later, when General Richard Montgomery was killed at the Battle of Quebec, Wooster became commander of all Continental army troops in Canada.

In 1777, in addition to being a major general in the Connecticut militia, Wooster was a brigadier general in the Continental army. In April, British general William Tryon landed with two thousand troops on the Connecticut coastline and marched north to Danbury, Connecticut, to capture and destroy American supplies. On their return south, they were attacked by

Wooster and about seven hundred of his men. Wooster was wounded and taken to Danbury, where he died five days later. Seventy-seven years later, Wooster's grave was identified, and a large monument was placed over his remains in Danbury's Wooster Cemetery.

NATHAN HALE

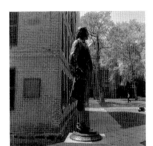

In 1914, Yale erected a statue of Nathan Hale in front of Connecticut Hall. Sculpted by Bela Lyon Pratt, the statue depicts the twenty-one-year-old Hale with his hands tied behind his back and his feet bound together shortly before he was hanged by the British as a spy in 1776. On the base are his reported last words: "I only regret that I have but one life to lose for my country." Copies of the statue stand at New Haven's Fort Nathan Hale (Black Rock Fort), the CIA Headquarters in Langley, Virginia, and several other locations.

Statute of American Patriot and spy Nathan Hale next to his former dormitory, Connecticut Hall. *Authors' collection.*

JOHN TRUMBULL

The Yale University Art Gallery includes many paintings of famous Revolutionary War scenes, such as *The Death of General Warren at the Battle of Bunker's Hill* (1786), *George Washington before the Battle of Trenton* (1792) and *The Declaration of Independence, July 4, 1776.* These and many more were painted by a man who met nearly every American leader in the war—Connecticut's John Trumbull.

Although a childhood accident left him blinded in his left eye, Trumbull became arguably the greatest painter of early American history. At the beginning of the Revolutionary War, he served as aide-de-camp to Washington. Toward the end of the war, the then twenty-four-year-old Trumbull was arrested and imprisoned in London in response to Washington's execution of British major John André in the Benedict Arnold affair.

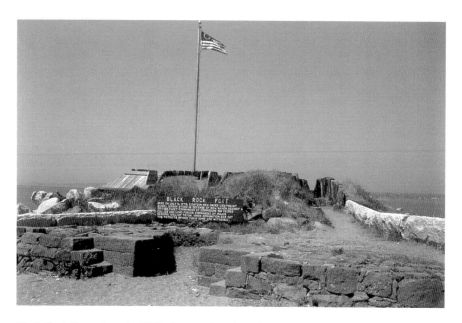

Black Rock Fort, where in 1779 nineteen American Patriots defended New Haven from British land and sea forces. *Courtesy of New England Photo.*

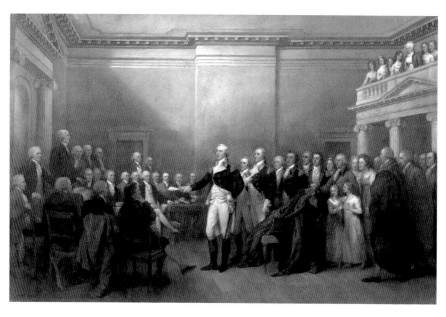

John Trumbull's painting *General George Washington Resigning His Commission*, depicting the commander in chief on December 23, 1783. *Courtesy of the Architect of the Capitol.*

At age seventy-five, John Trumbull gave a large collection of his historical paintings to Yale College in exchange for an annuity of $1,000 per year. Trumbull's agreement with Yale specified that all profits from the exhibition of these paintings were to go toward payment of the annuity and, after Trumbull's death, toward "defraying the expense of educating poor scholars in Yale College." The agreement further directed that the collection of Trumbull's paintings "shall never be sold, alienated, divided or dispersed, but shall always be kept together, and exhibited as aforesaid."

When Trumbull died in 1843 at age eighty-seven, he was buried underneath Yale's art gallery, which held his paintings. Twenty-four years later, the coffins of Trumbull and his wife, Sarah, along with his paintings, were moved to a new art gallery (Street Hall). In 1928, he and his wife's remains were moved again—to a third art museum. Unfortunately, the bottom of Sarah's ninety-four-year-old coffin broke open, dropping her bones to the ground. They were transferred to a new coffin, and both Trumbulls were interred under a stone slab that reads:

> COL. JOHN TRUMBULL
> PATRIOT AND ARTIST
> FRIEND AND AID
> OF
> WASHINGTON
> LIES BESIDE HIS WIFE
> BENEATH THIS
> GALLERY OF ART
> LEBANON 1756 NEW YORK 1843

Two of Trumbull's works appear today on U.S. currency: the portrait of Alexander Hamilton on a ten-dollar bill and the signers of the Declaration of Independence on the back of a two-dollar bill.

MEDAL OF HONOR

The Medal of Honor is the United States' highest medal for valor in combat that can be bestowed upon a member of the armed forces. New Haven's recipients of the Medal of Honor include the following men

who were either born or lived in New Haven. (Please note that there may be other Medal of Honor recipients who lived in New Haven sometime during their lives but do not appear on this list.)

Civil War

Daniel Webster Burke: Army, born and lived in New Haven.
Andrew H. Embler: Army, lived in New Haven.
Frederick Randolph Jackson: Army, born and lived in New Haven.
James T. Murphy: Army, lived in New Haven.

World War II

Robert Burton Nett: Army, born and lived in New Haven.

Vietnam War

John Lee Levitow: Air Force, lived in New Haven.
Daniel John Shea: Army, lived in New Haven.

Peacetime

Henry J. Manning: Navy, born in New Haven.

NEW HAVEN'S SOLDIERS' AND SAILORS' MONUMENT

New Haven's East Rock Park was designed by Frederick Law Olmsted (1822–1903), who is best known as the designer of New York City's Central Park. Near the summit of the park sits a monument that is visible from almost everywhere in New Haven. The Soldiers' and Sailors' Monument honors New Haven men who gave their lives in four major wars: the American Revolutionary War, the War of 1812, the Mexican War and the Civil War. The names of three battles from each of these wars are inscribed on the top of the monument's base.

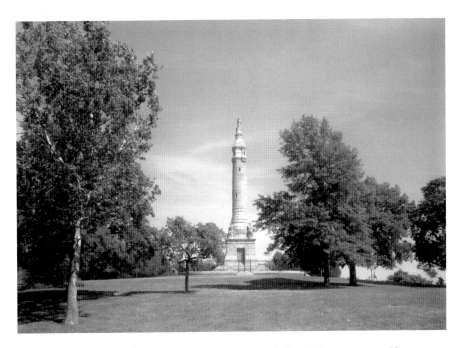

New Haven's signature monument is the Soldiers' and Sailors' Monument atop New Haven's East Rock. *Authors' collection.*

At the June 17, 1887 dedication of the monument, about 20,000 people marched in a parade that was viewed by 100,000 to 175,000 people. George W. Warner, who lost both of his arms in the Civil War, pulled a cord with his teeth to release a veil that covered the 112-foot-high monument. In attendance were Generals William Tecumseh Sherman and Philip Sheridan. At the time of the dedication, no veterans of the American Revolution still lived. However, many veterans of the other three wars were still living in 1887, with Civil War veterans averaging about fifty years old, most Mexican War vets being in their sixties and the few War of 1812 veterans being close to one hundred years old.

GEORGE W. WARNER

Union army private George W. Warner (1832–1923) of Company B, Twentieth Connecticut Infantry Regiment, lost both his arms at the Battle of Gettysburg. He was hit by the Union artillery's friendly fire while part of

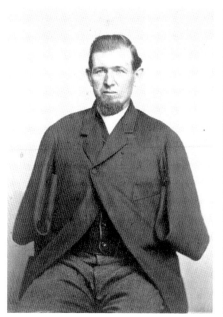
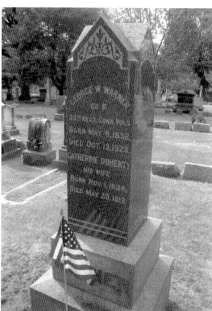

Left: Union army private George W. Warner, who lost both of his arms at the Battle of Gettysburg, made New Haven his home after the war. *Courtesy the Library of Congress.*

Right: Grave marker of Civil War survivor George W. Warner in New Haven's Evergreen Cemetery. *Authors' collection.*

an attempt to retake Culp's Hill from the Confederate forces. He left a wife and five children back home in Bethany, Connecticut, when he enlisted in the Union army in 1862; after he returned home, he and his wife had three more children. They moved to a home in New Haven on Edgewood Avenue. Warner passed away at age ninety-two and is buried in Evergreen Cemetery.

ANDREW H. EMBLER

Civil War Medal of Honor recipient Andrew H. Embler had a military record that would be difficult to match—he participated in nearly every major Civil War battle that occurred in the eastern United States. Born in New York in 1834, he enlisted in the state militia a few days after the Civil War began. In 1861, he was wounded at the First Battle of Bull Run. Promoted to captain, he was a unit commander at 1862's Battle

of Antietam, where he was wounded again. In 1863, Embler was at Gettysburg, and the following year, he participated in the Wilderness Campaign (where he received a minor wound).

In 1893, Embler was awarded the Medal of Honor for his actions on October 27, 1864, at the Battle of Boydton Plank Road in Virginia. The citation reads, "Charged at the head of 2 regiments, which drove the enemy's main body, gained the crest of the hill near the Burgess house and forced a barricade on the Boydton road."

In 1865, Embler witnessed Robert E. Lee's surrender at Appomattox Court House and was promoted to lieutenant colonel. After the war, Embler moved to Connecticut, where he was a founder (and shortly thereafter, treasurer) of a business that later was named the Southern New England Telephone, which began the first telephone exchange. The executive offices were located in one room on Orange Street. Besides the company officers, it employed only two clerks and a bookkeeper. When Embler retired from the telephone company in 1913, he was the last remaining of the original executive officers.

Embler also was a major in the Governor's Foot Guard, and in 1890, the governor of Connecticut appointed him adjutant general of the State of Connecticut. In 1918, he caught pneumonia while at a memorial service for New Haven soldiers who had died in France during World War I. He passed away several weeks later at age eighty-four. Embler and his wife are buried at New Haven's Evergreen Cemetery.

NEW HAVEN'S LAST CIVIL WAR VETERAN

In 1890, there were 6,946 living veterans of the American Civil War in Connecticut. When New Haven's Charles Douglass passed away in 1950, he was the last surviving one. Born in the city on May 23, 1847, Douglass enlisted as a drummer boy in the Fourth Connecticut Infantry at age fourteen. After recuperating from a bout of malaria, he reenlisted in the Fifteenth Connecticut Infantry. He participated in seven battles, including Fredericksburg, Nansemond River, Edenton Road and Providence Church Road. After his capture at Kingston, North Carolina, he was imprisoned in Richmond's Libby Prison.

The year Douglass celebrated his 100th birthday, the Veterans Administration revealed that there were only ninety-seven living Union

Evergreen Cemetery marker of Charles Douglass, who at his death in 1950 was Connecticut's last surviving Civil War soldier. *Authors' collection.*

army veterans of the Civil War on its pension rolls. The other ninety-six were spread over twenty-seven other states. At the time, Douglass compared war when he was young to war in the middle of the twentieth century. The difference, he said, was that today "there was more of it." On that occasion, he also stated: "Everybody has been so wonderful to me. I never dreamed anybody would notice me. Why, I've been treated like somebody important."

In 1949, Douglass was honored again, with his 102nd birthday party at his home at 290 Newhall Street in New Haven. The following year, he passed away and was buried at the city's Evergreen Cemetery next to his wife, who died sixty-seven years earlier.

WORLD WAR I

New Haven contributed a great deal to the war effort during World War I. Winchester Repeating Arms Company was a major supplier of armaments, and more than 260 New Haven residents died while serving in Europe.

Due to New Haven's significance as a manufacturer of weapons, 365-foot-high East Rock was important militarily during the war. Almost fifty soldiers were stationed on it, and artillery was installed on its 310-foot-high Indian Hill to guard against zeppelin attacks. Fortunately, such attacks never occurred.

WORLD WAR II's "ON TO VICTORY" PARADE

On July 4, 1942, only seven months after the Pearl Harbor attack, New Haven witnessed the largest crowd ever to attend a public event in the city. A quarter of a million people watched the "On to Victory" parade with its fifteen thousand marchers, seventy-five floats and thirty-two bands. Participants included thousands of service men and women, three thousand air raid wardens and other civilian defense employees and numerous workers from New Haven's war production factories.

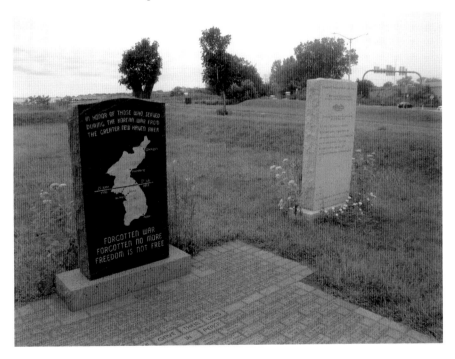

These monuments at New Haven Harbor honor New Haven area people who served during the Korean War and the fight against terrorism. *Authors' collection.*

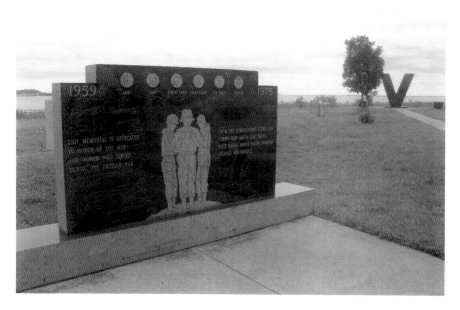

The monument in the foreground honors New Haven area men and women who served during the Vietnam War. The V-shaped monument remembers those who were killed, missing or taken prisoner. *Authors' collection.*

Much of the corporate section consisted of the nearly one-mile-long Winchester Repeating Arms Company contingent. This included five thousand Winchester workers, who sponsored a thirty-six-piece band and nine floats that displayed the steps involved in manufacturing guns for the armed services. Another corporation float from Bigelow Company was manned by workers who riveted a ship's boiler as they passed down the parade route.

In order to ease the flow of the participants and the spectators, the Civil Air Patrol employed an airplane to circle the city and look for traffic jams. It communicated with police on the ground via a two-way radio.

3

DISASTERS

As might be expected with a city the size of New Haven, disasters of almost all kinds have plagued its residents and visitors over the years. In this chapter, we cover everything from ships and aircraft in distress in New Haven Harbor to the collapse of a well-known pier. We learn about the death of a college football player during a key game and a bear mauling his zookeeper. In many cases, heroism was displayed, such as during the Rialto Theater Fire of 1921 and the Franklin Street Fire of 1957.

SCHOONER *JANE*

The schooner *Jane* of Bangor, Maine, ran up against rocks at the entrance of New Haven Harbor and sank at 2:00 a.m. on February 28, 1884. After the wreck was discovered six hours later, numerous valiant attempts were made by New Haven tugboats and yawls to rescue the *Jane*'s crew of four. Efforts were complicated by a forty-mile-per-hour gale-force wind blowing from the west, along with temperatures as low as six degrees Fahrenheit.

Ultimately, the hard work paid off—all were rescued. The last to be brought to safety was an older seaman, John Elsen of Brooklyn, New York, who, according to a *New York Times* article at the time, had been "exposed to the surf, the wind, and the cold" for thirteen hours. A key factor in Elsen's survival was the clothing that he wore: two suits of woolen clothes and

an oilcloth suit. When Elsen arrived at the hospital in New Haven, it was feared that his hands and feet would need to be amputated, but the medical personnel were able to save them.

The *Jane's* rescued crew included Captain A.G. Phillips of Maine, Henry Morris of New York and George Roberts of Cape Breton Island, Nova Scotia. New Haven's chamber of commerce and the Woman's Seamen's Friend Society provided the sailors with food, clothing and $1,200 to be divided among them. That wasn't an insignificant amount of money considering that men's shirts were selling for as low as $0.25 each and sugar was about $0.08 a pound. Also, the sailors received free tickets to New York City courtesy of the New Haven Steamship Company. Later, the Woman's Seamen's Friend Society had medals made commemorating the rescue and presented them to the survivors.

In the month following the rescue, a collection was taken up to raise a reward for the men who helped in saving the *Jane* sailors. New Haven area citizens awarded four of the men about seventy-five dollars each, and another thirteen men were given sixty-five dollars each.

Double Rescue of 1912

In July 1912, two teenagers accomplished two separate lifesaving rescues within the space of a few minutes off the New Haven shore. Seven-year-old Harry Condon had been carried "far out" into Long Island Sound by the wind. He had taken a canoe off Prospect Beach (then part of New Haven, now part of West Haven) when he lost his paddle. Nineteen-year-old Arnold Redmond, who was the son of the assistant chief of the New Haven Fire Department, was joined by New Haven teenager Reta Cox in saving the boy from drowning. They went after the boy in a rowboat. When they reached him, young Condon fell overboard and was about to sink when they grabbed him by the hair and pulled him into their rowboat.

As Redmond and Cox were returning to shore with the boy, they came across John Hilgert, who had fallen from his boat when he tried to reach for a lost oar. He was exhausted and on the verge of going under when Redmond and Cox saved him as well.

WEST HAVEN PILOT

On June 21, 1919, pilot Thomas Haggerty of West Haven was flying a passenger over New Haven Harbor when his plane dropped into the water. Two witnesses jumped from their sailboat, swam to the wreckage and cut the straps that were holding the two flyers in. Although Haggerty was underwater a long time, he survived.

TWO ZOOKEEPERS ATTACKED
AT THE EAST ROCK PARK ZOO

In the early twentieth century, a small zoo on the top of East Rock was popular with many local residents and staffed with several zookeepers. In 1916, $1,405 of East Rock Park's expenditures of $18,964 went toward the zoo. A 1918 history of New Haven listed the inhabitants as "a number of bears, some guinea pigs, hares, peacocks, pheasants, guinea hens, and bronze turkeys." At various times, donated animals included a parrot, a South American monkey and two burros.

In 1930, the head keeper was seventy-four-year-old Gustave Anderson (1856–1930), who with his wife, Anna, had emigrated from Sweden. His seven-year-old grandson, George Sabine Jr., would often accompany him to the zoo's bear enclosure to see its two Canadian bears. First, they would

In the early 1900s, a small zoo was located near this area of East Rock Park, which is near its State Street entrance. *Authors' collection.*

stop at a drugstore near State Street to buy a nickel package of cherry cough drops. When they reached the zoo, little George would not be allowed too close to the bears, but he would carefully put the cough drops on a shelf in the cage.

For eight years, Gustave Anderson cared for the largest bear, named Teddy. On November 22, 1930, he was attempting to move the five-hundred-pound animal to another cage when it savagely attacked him. As Anderson was being mauled, a second keeper, twenty-two-year-old Louis Warner, came to his aid—although he didn't have time to secure a weapon. The bear mauled Warner's legs when he tried to fend off the animal with his bare hands. Then, a third keeper, Earl Morris, entered the cage with a mallet and pounded the bear's head until it released Warner.

The bear escaped into the woods; shortly afterward, it was hunted down by police and East Rock Park workers. New Haven's Marlin Arms Company loaned them high-powered rifles for the search. When the bear returned to the zoo on its own, it was pushed into a cage by men using brooms as torches. A few days later, the bear was euthanized. Three days after the attack, Gustave Anderson died from his wounds at New Haven's Grace Hospital. The city sent a condolence card and a bouquet of flowers to his family but didn't pay anything toward the funeral expenses.

According to Anderson's great-granddaughter Donna Maturo, Gustave had developed a rapport with the bear. It was rumored that someone had teased the animal shortly before the tragic attack. A *New Haven Register* article at the time stated that the bear "has always been docile and has never before created a disturbance. He had become particularly attached to Anderson in the eight years which he has spent in his care."

In 1931, the Connecticut Humane Society presented Warner and Morris with medals for heroism in their attempts to save their fellow keeper. Anderson's grandson George Sabine Jr. remembered the bear attack for the remaining eighty-one years of his life, passing away at age eighty-eight in 2011. His life included time studying veterinary medicine at the University of Connecticut, and he was the recipient of two Purple Hearts for his service in the U.S. Army during World War II.

DEATH AT YALE BOWL

Only one player has ever been fatally injured in a football game at Yale Bowl. On October 24, 1931, during the annual Yale-Army game before seventy thousand fans, Army right end Richard Sheridan Jr. tackled Yale player Robert Lassiter on the twenty-two-yard line. Other players piled on the two men. When they got up, the West Point cadet remained on the ground. Even as they carried the unconscious Sheridan away on a stretcher, no one knew the seriousness of his injuries.

Among the spectators that day was Dr. Samuel Harvey, who was the chief surgeon at New Haven Hospital. He examined Sheridan in the ambulance, gave him artificial respiration and ordered the driver to rush to the hospital. Further examination revealed that Sheridan had fractured two vertebrae— he had a broken neck.

Efforts to save Sheridan were aided by the fact that the hospital was hosting a national convention of brain specialists. According to a *New York Times* article at the time, this resulted in "an effort almost without precedent in surgical annals to save the life of the stricken athlete." Joining Sheridan's family at the hospital were the commandant of West Point, its Catholic chaplain and Yale football team captain Albie Booth. Although Sheridan was placed on a mechanical respirator, he died two days after his injury.

PIER COLLAPSE OF 1933

On Saturday, August 26, 1933, a section of the wooden pier at Lighthouse Point on the east side of New Haven Harbor collapsed. At least seventy-five of the people who had gathered to view a cross-harbor swimming race were thrown into the water, including the judges. Since many of them fell head first into the fourteen-foot-deep water, it was feared that some had drowned in the confusion and panic.

Although twenty-seven of the victims were injured, miraculously no one was killed. Undoubtedly the lack of fatalities was due to the quick action of lifeguards, contestants in the race, other swimmers, local firefighters and boaters who were gathered in the area to view the race. They immediately rescued dozens of children, women and weaker swimmers. All available ambulances in New Haven rushed to the scene, as did medical doctors from the three local hospitals: New Haven Hospital, St. Raphael's and Grace.

Five people required hospitalization, although their injuries were not believed to be serious. One was seventy-year-old Mary Sullivan, whose son Alex Sullivan was the winner of the race. Three of the others were treated for shock and one for an arm injury. One of these was saved by Yale University wrestling instructor Ed O'Donnell, who subsequently jumped back in the water to also rescue a mother and her two-year-old baby.

The pier, which served as a ferry dock, had been packed with people, who, despite police orders to the contrary, rushed to the pier's end to view the finish of the race. After the pier collapse, police, using searchlights, dragged the waters for two days until they were confident there were no bodies to be found.

Autogyro Crash of 1934

On May 22, 1934, twenty-seven-year-old Pennsylvania aviator Fred "Slim" Soule almost met with disaster in New Haven. At the time, he had only been married for five weeks. He was flying over the center of the city in an autogyro, which was a rotary-wing aircraft similar in appearance to a helicopter. Soule was towing an advertising banner when at about three thousand feet above the New Haven Green, his engine burst into flames. Instead of parachuting out immediately and possibly endangering the lives of many people in the densely populated city, he stayed at the controls until the aircraft reached Waterside Park. At the last minute, he saw about two hundred children playing in the park and changed his course to land in the waters of New Haven Harbor. Soon, the motor died, and Soule parachuted the short distance to the water, where within minutes, he was picked up by one of two dozen small boats that had sped to his rescue.

Working for the Horizon Aerial Advertising Company, Soule is said to have flown more hours in an autogyro than anyone else in the world. However, the autogyro's inability to hover resulted in this aircraft losing out to the more efficient helicopter. After World War II, Fred Soule became one of the country's most experienced helicopter test pilots. He died in 1995 at age eighty-eight.

NAVY FLIERS CRASH LAND IN LONG ISLAND SOUND IN 1953

At about 6:30 p.m. on December 3, 1953, two U.S. Navy fliers crash landed in Long Island Sound south of New Haven Harbor. Twenty-five-year-old pilot James Shapiro from New York City and thirty-one-year-old radar operator Donald Sockman were flying a Grumman Guardian on a routine training flight from Quonset Point, Rhode Island Navy Air Base, when their engine failed. Rather than head south and possibly endanger people in cottages on Long Island beaches, Shapiro headed toward New Haven Harbor. Gliding 2,500 feet above the water, the men went through the ditching procedures. At 1,000 feet, the fog forced Shapiro to switch to his instruments. Shortly afterward, he landed the plane intact on the choppy water.

As Sockman climbed out on the starboard wing, he saw that Shapiro was struggling to get out—his parachute was entangled in the life raft. "Hurry up, the nose is going down!" shouted Sockman. Shapiro finally broke free and climbed onto the port wing. They abandoned the plane, which disappeared in less than two minutes.

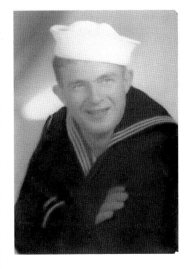

Navy radar operator Donald Sockman survived a crash landing south of New Haven Harbor because of his new Mark IV exposure suit. *Courtesy Donald E. Sockman Jr.*

Sockman and Shapiro were both wearing the new Mark IV exposure suits. Although their faces and hands were exposed to the near-freezing water, the suits and the attached boots were waterproof. They struggled to inflate their six-foot-long one-man rafts and then, after drifting one hundred feet apart in the dark, fought to lash them together.

After news arrived of the missing fliers, their home base in Quonset Point sent planes, Coast Guard cutters were dispatched from Long Island and New London, two submarines surfaced and headed to the crash site, Grumman Corporation sent an amphibious aircraft and pleasure craft from New Haven headed south. The search had to be abandoned at about midnight because of the dense fog. Shapiro and Sockman decide to save their strength by not trying to paddle to shore until daybreak.

The commander of the fliers' Air Antisubmarine Squadron 24 in Rhode Island went to Sockman's wife to tell her that her husband was missing. Today, son Gene Sockman remembers being taken out of his second grade classroom and brought home to be with his mother as she waited for word of her husband. Before 7:00 a.m., twelve Grumman Guardian planes headed toward New Haven Harbor in search of the missing men. As the men on the rafts saw the first plane, they sent up a smoke flare. The first to arrive at the rafts was a Coast Guard amphibian. It was about 8:00 a.m.

After their rescue, Sockman and Shapiro were examined by navy doctor John Bryan, who pointed to their exposure suits and stated, "There's the reason you are alive today. Without it I don't think you could have survived thirteen hours in a raft in that temperature." Sockman and Shapiro agreed. The exposure suits were composed of an outer rubberized nylon with a quilted nylon lining. They were tested the year before at the New Hampshire's Mount Washington, which holds the world record for the highest wind speed ever recorded—except for tropical cyclones.

After his military service, James Shapiro became a successful businessman in Europe. Donald Sockman retired from the navy with twenty years of service in 1963. He passed away in 2009. After his rescue, Grumman Aircraft Corporation sent him a model of the *Guardian*. As of 2018, the model plane was still hanging from the ceiling of the Sockman family homestead.

RIALTO THEATER FIRE OF 1921

On November 27, 1921, the Rudolph Valentino movie *The Sheik* was scheduled to be shown at New Haven's Rialto Theater. In a lead-in to the movie, incense was burned onstage, and it set nearby flimsy drapery on fire. Soon, the front of the theater became an inferno. Situated across the street from the Taft Hotel at 80 College Street, the Rialto was filled beyond capacity that evening, and according to witnesses, the stampede of people trying to leave the building jammed the aisles and exit doors.

One theatergoer, Louis Goodman, was quoted as saying, "A woman had just finished singing on stage, and the film was being shown. I saw a little smoke and a light which I thought had something to do with the production. Then I saw a piece of blazing material fall from the top of the stage....[I]t was followed by a burst of fire." Some men jumped from the balcony onto people on the main floor.

Some of the heroes in evacuating people from the burning theater were members of the Yale University football team. One was a twenty-five-year-old World War I veteran, Reginald C. Batty, who also was a member of the Yale's freshman wrestling team. The 220-pound, six-foot-five athlete dragged a man out with one hand and a woman with his other, while pushing a third person before him. Batty then went back into the burning building and rescued two more women, pulling one by the leg and the other by her coat collar.

Batty's grandson Harold Andrew "Andy" Batty Jr., who grew up in the same large family farmhouse as his grandparents, told the authors that Grandfather Reg was "strong as a bull with huge hands." Granddaughter Susan Batty Santoski, Andy's sister, remembers

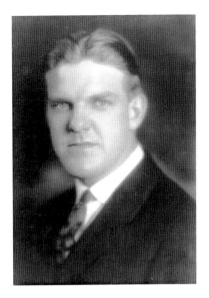

A hero of the Rialto Theater Fire of 1921, Reginald C. Batty (1895–1986), was about twenty-nine years old when this photograph was taken. *Courtesy Susan Batty Santoski.*

that her grandfather's gold wedding band easily fit over two of her fingers, while Reg's wife (and her grandmother), Irma, was so small that her wedding band fit her pinkie finger. Andy also noted his grandfather was "a stubborn Englishman, who was independent, proud, fair, and always wanted to do the very best thing."

Reg's great-granddaughter Teresa Santoski has researched her ancestor's life and discovered that one of the Yale football team's "favorite plays" had been to score by having Reg Batty throw a lightweight, ball-carrying teammate over the defensive line into the end zone. An alternative play involved having a small player running up Reg's back and leaping into the end zone. Both maneuvers were later prohibited by collegiate football rules.

After Reginald Batty received his mechanical engineering degree from Yale in 1924, he married Irma, who had been a nurse in World War I, and started a successful engineering career that culminated with his position of chief engineer for American Locomotive in Auburn, New York.

After the Rialto Theater Fire, scores of people were transported to New Haven Hospital and St. Raphael's Hospital. Ten people died in the fire, and over one hundred suffered burns.

Four weeks after the fire, the coroner released his findings that three people were at fault: the building inspector, who allegedly did not enforce the building codes; the theater manager, who staged the event that caused the fire; and the president of the company that managed the theater chain and allegedly did not obey state and city fire laws.

THE 1941 FRANKLIN STREET FIRE

On February 5, 1941, a fire at the New Haven Quilt & Pad Company at 82–88 Franklin Street claimed the lives of ten men. The company was in the business of manufacturing army blankets. According to the obituary of Anthony Celotto of East Haven, he was the last survivor of the New Haven Quilt & Pad fire. A longtime employee of the Southern Connecticut Gas Company, he passed away in 2011 at age ninety-four.

A month after the fire, a report by consultant Joseph Tone to the U.S. secretary of labor stated a new commission had already set about writing new fire laws:

> It appears to me that these dead men have not been martyred in vain.... Personally, I believe that this building was the wrong type for processing such flammable goods as combed cotton....However, I haven't much confidence in fire escapes but I do believe in fire towers...with a fire escape it is always possible for the flames to reach the escape before the occupants, thus preventing their using it....I believe the machines themselves should be enclosed, possibly by brick walls, to prevent the cotton from blowing around the shop.

Significantly, Tone stated in his report:

> Connecticut is without adequate legislation. The law doesn't state the types of fire escapes and where they should be enclosed or screened, or located. There are no laws limiting number of employees or occupancy; there are no laws providing for fire drills or fire alarm signal systems. The law does not state that the escapes or stairways shall be at a remote end of the building.

Unfortunately, the State of Connecticut did not follow through with adequate fire protection measures, and sixteen years later an even more

deadly fire occurred in a similar factory building on the same New Haven street. Many of Tone's recommendations would have either prevented the fire or, at least, resulted in fewer causalities.

THE 1957 FRANKLIN STREET FIRE

On December 2, 1952, veteran James D. Curry Jr. was appointed New Haven's first African American fireman by the city's board of fire commissioners. The thirty-two-year-old Curry had served as a lieutenant in World War II.

Years later, on January 24, 1957, Curry would be one of the fireman who helped rescue the survivors of New Haven's deadliest fire. Fifteen people burned to death in a four-story nineteenth-century factory building on Franklin Street. The first floor was occupied by the Thomas Machinery Sales and S.L. Stanley Co., the third floor by Andy-Tommy and Morris Baer Dress companies and the fourth floor by Nylco Manufacturing Co. and the Jo-Al Dress Co.

Many of the dead were women garment workers who were unable to escape the building. Six of them became trapped on the fire escape. Curry was the first firefighter to rescue some of the women. As Frank Myjak, who also helped save lives that day, explained to the authors, "Curry backed his truck in, pulled out a water cannon, and saved a lot of people by spraying them to keep the fire away."

Frank Myjak, who would later go on to a distinguished forty-year-long career with the Branford Police Department, remembers the day well. "It was the most frigid January day I ever saw." He was a twenty-year-old worker in his elder brother Stanley's steel-fabricating shop on the first floor of the Franklin Street factory. He had just returned to the shop after making a parts delivery when he saw smoke and flames shooting from the rear of the structure. He was met by Stanley, who was shouting, "Get out of the building! Don't go back in!" as he was dragging people away from the burning structure. Frank Myjak remembers, "Those people lived. God was with them that day."

Besides James Curry and Stanley and Frank Myjak, other heroes who helped save lives that day included the Myjaks' cousin Thomas Dobroski and their brother Walter Myjak. Standing on the roof of a car, Dobroski helped several women climb to the ground from the fire escape. He yelled for other victims to jump, but they were too afraid and several of them died

on the fire escape. Walter Myjak retrieved an old wooden ladder from the burning building and set it against the fire escape, and his brother Stanley found a hammer, which he used to remove a pin that someone had inserted to prevent the fire escape from reaching the ground. Stanley pulled the fire escape down, and six or seven charred bodies fell to the ground. Other women, severely burned, but still alive, jumped or tumbled over the bodies and were helped by Dobroski and the three Myjak brothers.

Frank Myjak told the authors, "Flames came out of the windows onto the fire escape. When my brother pulled out the pin, most were already burnt to death. Their skin came off on our fingers when we lifted them down. There would have been more than 15 dead if Stanley had not pulled the pin out." He emphasizes that the New Haven Fire Department "did a great job that day."

Because of the large number of victims that needed to be transported to area hospitals, hearses were also used because there were not enough ambulances.

The fire so weakened the factory building that it soon collapsed from the additional weight of the ice formed from the water used to extinguish the fire. Later, much of Franklin Street was demolished to make room for Interstate 91. The Harry A. Conte West Hills Magnet School now sits on the site of the factory building.

CRASH OF ALLEGHENY AIRLINES FLIGHT 485

By far the worst disaster at Tweed–New Haven Airport was the Allegheny Airlines Flight 485 crash on June 8, 1971. Twenty-eight passengers and crew members died after the Convair CV-580 airliner plowed into three East Haven beach cottages while attempting to land at the airport. Only the co-pilot and two passengers survived.

Twenty-seven of the fatalities occurred because of fire when the exit doors could not be located or opened. The National Transportation Safety Board (NTSB) report on the crash stated: "[E]veryone aboard this flight [except the captain, who died on impact] could have survived if rapid egress from the fire area had been possible or if flame propagation had been retarded." It also stated that more people would probably have survived if there had been two cabin attendants instead of one.

The NTSB found the probable cause of the accident was "the captain's intentional descent below the prescribed minimum descent altitude under

adverse weather conditions" and concluded it was "unable to determine what motivated the captain to disregard prescribed operating procedures and altitude restrictions, and finds it difficult to reconcile the actions he exhibited during the conduct of this flight."

All three survivors of the crash are now deceased. Co-pilot James Alford Walker, aged thirty-four at the time of the accident, died in 2011 at seventy-four. He lost both of his legs as a result of the crash and became a Memphis, Tennessee musician and record producer. Janet McCaa, an attorney for the National Labor Relations Board, died in 2016 at age seventy-three. Norman Kelly of Waterford, Connecticut, died in 2012 at age eighty.

Kelly's daughter Nancy Kelly told the authors about that day: "I was home sick that day and went with my father to the Groton airport. I told him, 'I have a feeling you're never coming home.' I didn't want him to go. I was crying, I was upset there would be a problem." Mr. Kelly flew out to New Haven with two coworkers from Electric Boat. He survived; they did not. Nancy remembers him relating that in the smoke and confusion after the crash, he thought everyone had gotten off the plane and he was the last to leave.

Norman Kelly was one of only three people to survive the crash of Allegheny Airlines flight 485 at Tweed–New Haven Municipal Airport in 1971. *Courtesy Kelly's daughter, Nancy Kelly.*

After the crash, Nancy Kelly was bothered that she never got to see her father come through the airport doors to greet her. After the very long time it took him to recover from his injuries, she asked if they could go to the airport to walk through the doors he would have gone through if the accident had not occurred. They received permission from airport authorities to walk the wrong way through the exit doors so they could reenact the homecoming that they would have had if everything had gone well back in June 1971.

Buried Alive

In addition to the horrible disasters caused by fire, airplane crashes, and drownings, there were other dangers facing ordinary workers, such as the chance of being buried alive. In 1888, laborer Michael Quinn was working on a sewer excavation in New Haven when six feet of sand slid onto him. Local man George Murphy described the attempt to save Quinn: "I seized a shovel and began to dig and gave directions to the other men willing to help. The soil was dry and as fine as scouring sand, and almost as rapidly as we dug, the space would fill up again."

A medical doctor named Reilly and a Catholic priest named Sullivan arrived, and Murphy put his leg through the sand and felt Quinn's head. He used his foot to raise the trapped man's head to enable him to breathe. But Dr. Reilly examined Quinn's head and pronounced him dead. As soon as Murphy and the doctor climbed out of the hole, sand filled it in and covered Quinn again.

In 1955, an almost identical situation evolved. New Haven resident Robert Eaton, while working for a city plumbing company, was digging down to a sewer pipe in Townsend Avenue when soft soil slid back in, totally covering him. It took firemen and volunteers a half hour before they were able to clear away the sand, which kept refilling the hole. By the time Eaton arrived at Grace–New Haven Hospital, he was dead.

Fortunately, not all cave-ins end in tragedy. A year and a half before Eaton's accident, sixty-two-year-old worker Sebastian Guarnieri became trapped up to his shoulders by sand in an eleven-foot-deep ditch. When thirty-one-year-old plumber Victor Popolizio jumped in and tried to free Guarnieri, another dirt slide covered the trapped man completely. Popolizio uncovered Guarnieri's head to enable him to breathe and went to a nearby house to ask that police be called. When he returned to Guarnieri, he discovered the man's head was again covered with sand. He cleared it away as firemen arrived with oxygen for the victim. Due to Victor Popolizio's efforts, Guarnieri survived and was able to walk to a waiting ambulance.

Mary E. Hart

New Haven's most famous case of live burial didn't involve workmen. Since 1848, the eighty-five acres of Evergreen Cemetery have seen eighty-five thousand interments. Perhaps none is better known than Mary Hart's. Forty-eight-year-old Mary E. Hart passed out in her home at noon on October 15, 1872. Twelve hours later, at midnight, she was declared dead. Her family had her buried in the city's Evergreen Cemetery. A day or so later, Mary's aunt dreamed her niece was still alive in her coffin and the family had her exhumed.

What they found was beyond horror: the inside of the coffin's lid was scratched, Mary's fingers were bloody from trying to claw her way out, and her face was frozen in a look of abject horror. Today, a large marker sits above Mary's grave. Its inscription reads:

> *The People Shall Be Troubled At Midnight And Pass Away*
> *At High Noon*
> *Just From, And About To Renew*
> *Her Daily Work In Her Full Strength Of*
> *Body And Mind*
> *MARY E. HART*
> *Having Fallen Prostrate*
> *Remained Unconscious Until She Died At Midnight*
> *October 15 1872.*

Today, a legend persists that "Midnight Mary," as she is commonly called, is still to be found wandering through Evergreen Cemetery in the dead of night.

4

EDUCATION

New Haven is not only known for Yale University. It has always been the home of fine primary and secondary schools, as well as other colleges and universities. We briefly cover some of them here.

HOPKINS SCHOOL

The Hopkins School is the third-oldest independent secondary school in the United States. Founded in 1660, the Hopkins Grammar School was established through a charitable trust created by Edward Hopkins, who was the second governor of the Connecticut Colony. The school's first teacher was Harvard-educated minister Jeremiah Peck, who taught for two years (1660–62) before becoming pastor of the congregational church in Guilford, Connecticut.

Originally, the school consisted of a one-room building on New Haven's town green. In 1926, it moved to its present location near the city's western town line. Another milestone in Hopkins's history was reached in 1972 when it merged with Day Prospect Hill, a women's school.

Students of the Hopkins School have included: Roger Baldwin, who represented the Africans in the famous *Amistad* court case; Walter Camp, who is often called the "Father of American Football"; and several presidents of Yale University.

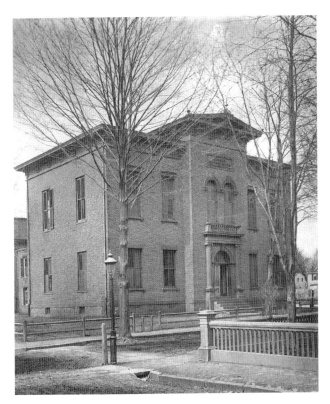

Left: The Hopkins School (pictured here in 1873) is the third-oldest independent school in America. *Courtesy the Hopkins School.*

Below: Day School Gym Drill at the Hopkins School. Hopkins and Day Prospect Hill merged in 1972. *Courtesy the Hopkins School.*

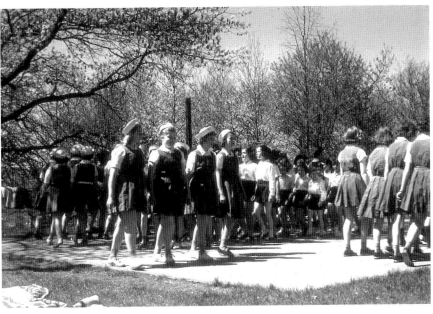

In 2010, Yale University president Richard C. Levin and Jane Levin, the parents of four Hopkins students and themselves former school trustees, attended a ceremony recognizing the 350th anniversary of Hopkins School. That day, President Levin stated that "the School's strength also derives from the wisdom of its founders: Edward Hopkins, who gave the School its mission, and John Davenport, who gave it good governance. It has been an honor and a privilege to serve an institution so worthy and enduring."

BOARDMAN MANUAL TRAINING SCHOOL

Built in 1894 with donations from Lucy Boardman, the Boardman Manual Training School on Broadway was the first technical high school in New Haven. In the early years of the school, some people imagined that its purpose was to limit people to manual work and neglect academic studies; however, the experience of graduates showed this to be untrue, as they excelled in many occupations. Boardman differed from most other manual training schools in its insistence that students not only practice manual task skills but also produce useful objects. These were never sold—students could choose to take their works home or leave them at the school. Boardman later merged with Hillhouse High School.

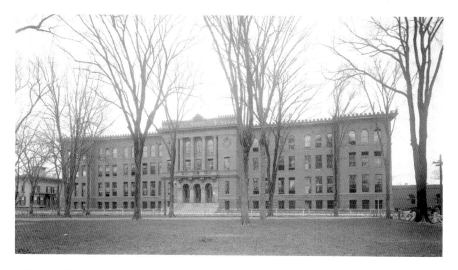

Hillhouse High School circa 1900–15. Hillhouse students have included musician Artie Shaw, actor Ernest Borgnine and John C. Daniels, New Haven's first African American mayor. *Courtesy the Library of Congress.*

NEW HAVEN HIGH SCHOOLS

Wilbur Cross High School and Hillhouse High School are New Haven's two largest public secondary schools. Magnet schools in the city include the Cooperative Arts & Humanities Interdistrict Magnet and the Sound School Regional Vocational Aquaculture Center. In addition to the well-known Hopkins School, other private secondary schools accept students.

SOUTHERN CONNECTICUT STATE UNIVERSITY

Southern Connecticut State University was founded in 1893 as the New Haven State Normal School. This two-year teacher training school held its first classes at New Haven's Skinner School on State Street—there were three instructors and eighty-five female students. Its first principal was Maine-born, Yale-educated Arthur Boothby Morrill (1853–1926), who had formerly worked at the State Normal Schools in New Britain and Willimantic. Morrill served as the New Haven school's principal until his retirement in 1924.

Tuition and textbooks were free at the early New Haven State Normal School, but students were required to sign a contract in which they agreed to teach in Connecticut. In 1896, the growing school moved to a building on Howe and Oak Streets.

In 1937, the school became a four-year college and offered bachelor's degrees. By the 1950s, the school, now named the New Haven State Teachers College, established its own graduate school programs and moved to its current location on Crescent Street in the far west section of New Haven. Two more name changes reflected its growth and expanded mission: Southern Connecticut State College in 1959 and Southern Connecticut State University in 1983. Today, the university is commonly known as simply Southern or SCSU. Despite branching out into many academic areas and professional concentrations, the institution remains a major provider of teacher education.

ALBERTUS MAGNUS COLLEGE

Albertus Magnus College is the only college in the United States named for German bishop, philosopher and theologian St. Albertus Magnus (Albert the Great) (circa 1200–1280). In 1925, it was established as an all-women liberal arts residential college in northern New Haven by sisters of the Roman Catholic Church's Dominican Order. Although Albert was recognized by the Vatican at the time with the pre-canonization title "Blessed," he was not declared a saint until six years after the college took his name.

Albertus Magnus College purchased the buildings and grounds of businessman and polo champion Louis E. Stoddard's Ten Acres estate. Stoddard's 1906 mansion, which was designed to resemble the White House, was renamed Rosary Hall and became the location of the new school's classes and administrative offices. Today, that building serves as the Albertus Magnus College library and computer center, and it is still the largest house in New Haven.

In the college's opening years, it benefited from the services of many renowned Yale professors, including Professor Nicholas Moseley, who taught Latin and Greek, and Professor John Edward McDonough, who taught economics. The first graduating class was in June 1929, with a baccalaureate mass held in St. Mary's Church and a sermon by Yale's Catholic chaplain Father T. Lawrason Riggs. The following year, eleven instructors were added to its faculty, bringing the total up to twenty-five—a large number for a school whose total student population was only about eighty-five.

Over the next nine decades, the college acquired additional mansions and constructed several new buildings. Since 1985, it has been coed. Today, the college still proclaims a Dominican heritage and has the most racially diverse student body of any small college in Connecticut.

GATEWAY COMMUNITY COLLEGE

In 1992, New Haven's South Central Community College merged with the North Haven–based Greater New Haven State Technical College to form Gateway Community College. For two decades, Gateway maintained two campuses: one at Long Wharf Drive in New Haven and one at a former high school in North Haven. In 2012, Gateway moved its courses to a new

358,000-square-foot, four-story main campus building in downtown New Haven. It is two blocks south of the New Haven Green on the northwest corner of Church and George Streets (the site of the former Chapel Square Mall). Only the college's Automotive Technology Center remained at the North Haven facility.

In the early twenty-first century, New Haven's Gateway Community College, with over seven thousand full- and part-time credit-seeking students, surpassed Manchester Community College to become the largest of Connecticut's state community colleges.

5

YALE UNIVERSITY

Established in the southern portion of Killingworth, Connecticut (now the town of Clinton), in 1701, Yale University began as the "Collegiate School." It moved to New Haven in 1716 and was renamed Yale College after British East India Company president Elihu Yale, who had donated items, including over four hundred books. In 1887, it received its current name, Yale University.

CONNECTICUT HALL

In 1752, a new residence hall at Yale College named Connecticut Hall was funded by three sources: a grant from the Connecticut General Assembly, a lottery and the sale of a French ship that was captured by a privateer. Three other major eighteenth-century New Haven projects were funded by lotteries: two wharfs and a bridge over the Quinnipiac River. Today, after spending two centuries as a residence hall and many more years as an administration building, Connecticut Hall is the oldest surviving building on the Yale campus.

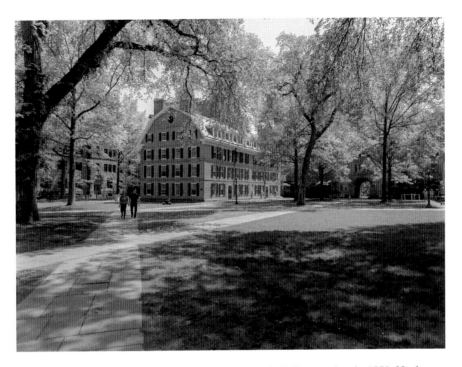

Connecticut Hall was Nathan Hale's home while a Yale College student in 1773. Noah Webster and Eli Whitney also lived here, in 1778 and 1792, respectively. *Authors' collection.*

STUDENT RIOTS

A riot occurred in 1911 when students trashed the auditorium of one of the city's major theaters. The *New Haven Union* headline read, "Worst Student Riot in History Results in Wrecking of Hyperion and Seven Arrests." Apparently, this was not unusual, as a contemporary *Hartford Courant* article was titled "Town-Gown Riots Bane of New Haven."

On the day of the Hyperion Theater riot, the manager expected that students would be in a rowdy mood because he expected them to be celebrating a big victory of Yale over Princeton in the afternoon's football game. Thus, planning on constant interruptions by the audience, he estimated the first act of the scheduled three-act play would be enough to occupy the evening. However, Yale lost to its rival, and the students were in little mood to celebrate—but they were in a state to make trouble when they discovered the show was ending prematurely. The vandalism began as one student in a

front box threw a chair through the curtain, and other students proceeded to push over brass railings and destroy chairs. Stage hands reacted by turning a fire hose on the audience.

In the days following the disturbance, the Hyperion manager apologized for the conduct of the management and offered to replace any clothing damaged with the hose. He stressed his desire for continued "friendly relations" with Yale students.

RIOT OF 1854

The 1911 riot paled in comparison with another incident between Yale students and townspeople decades earlier. In March 1854, about half a dozen students were attending a play in New Haven's Homan's Athenaeum Theater, which stood at the corner of Chapel and Church Streets, when an argument erupted between one of them and another audience member. When the students left the theater, a crowd of people attacked them with clubs. In the fight, the students' cry of "Yale! Yale!" attracted fellow students, who joined in the melee. Police arrested two or three students along with the mob's leader, barkeeper Patrick O'Neil—all of whom were only detained for a few hours.

The next day, over 50 Yale students gathered at the theater for another play. Meanwhile, a mob of about 1,500 people had assembled outside the front entrance. When the students left the building, they were greeted with "hisses, hootings, groanings and insulting cries." Ignoring the taunts, the students filed up Chapel Street to Temple Street. At Trinity Church, the mob began throwing stones and bricks. The students fired bullets into the air and into the crowd, slightly wounding one man in the arm. Mob leader O'Neil fell wounded of a suspected gunshot and died within minutes. Later, it was found that he had been stabbed with what was thought to be a bowie knife.

As news of O'Neil's murder spread, mob participants at the police station threatened to tear down Yale College, while between five and six hundred of their comrades broke into the New Haven armory, stole two cannons and transported them to the Yale campus. As some mob members filled the guns with chains, bricks and stones, others broke into nearby churches and rang the bells of the Center and Court Street churches to attract reinforcements. The mayor of New Haven stood on top of one stolen cannon and pleaded

with the rioters to stop and go home. During the confusion, New Haven's chief of police Lyman Bissell ordered his men to secretly disable the cannons, rendering them useless. Discovering this, the attackers showered Yale's South College building with paving stones and bricks, all the while yelling, "Bring out the murderer." Chief Bissell was able to talk the crowd out of further violence, promising that O'Neil's killer would be brought to justice. The police confiscated the cannons, and the mob dispersed.

Jurors at a court of inquiry convened three days after the event concluded "that O'Neil's wounds were 'at the hands of some person or persons to us unknown'—the said Patrick O'Neil being at the time engaged in, and leading, aiding, and abetting a riot." O'Neil's murder has never been solved. Chief Bissell, who in later years would serve as an officer in both the Mexican-American War and the Civil War, died in 1888 at age seventy-six.

YALE COLLEGE'S ASTRONOMICAL OBSERVATORY

The Atheneum was Yale College's first astronomical observatory. Established in 1830 in a tower, it had the largest refractor telescope in the United States. The five-inch custom-made Dollond telescope cost about $1,000 and was donated by Oxford farmer Sheldon Clark (1795–1840). Without a family or a formal education, the frugal Sheldon had saved both a large inheritance, as well as the profits from his farm, and ultimately donated many thousands of dollars to Yale. Between 1823 and the time Clark died in 1840, he gave in life or left in his will over $30,000 to Yale College. That was over three times as much as any other individual had ever given up to that time (between 1701 and 1840).

The observatory's telescopes have included: a nine-inch Alvan Clark refractor (1870), a heliometer (1880) and an eight-inch telescope (1882). The observatory was the first in the United States to make a sighting of the return of Halley's Comet in 1835, and over the centuries, it is credited to have contributed an incredible amount to the knowledge of meteors and the motion of the axis of the earth.

In 2008, the observatory was renamed the Leitner Family Observatory and Planetarium. Today, the institution is at Farnham Memorial Gardens, which is near the corner of Edwards and Prospect Streets. It hosts weekly planetarium shows and allows the general public to use its eight-inch Reed refractor to view planets and stars.

ASTRONOMER IDA BARNEY

Ida Barney (1886–1982) was a Yale University astronomer who catalogued about 150,000 stars over a thirty-year period. Using her mathematician skills, Barney made measurements of stars more accurate by streamlining the process.

Born in New Haven in 1886, Barney attended New Haven High School from 1900 to 1904, graduated from Smith College in 1908 and received a PhD in mathematics from Yale University in 1911. She taught at Smith and other colleges prior to joining the Yale University Observatory in 1922 and lived the last sixty years of her life in the New Haven area.

Soon after joining Yale, Barney participated in what has been called "one of the most intensive photographic mapping jobs ever undertaken by a single observatory." At the retirement of Yale observatory's director in 1941, Ida Barney became director of the project. Decades before the advent of modern computers and the Hubble Space Telescope, the twenty-three-year-long project charted one half of the sky, measured 128,000 stars and made 500,000 measurements.

In 1950, Yale University completed the thirteen-volume Yale photographic zone catalogues. In 1952, Ida Barney received the American Astronomical Society's Annie J. Cannon prize for her "distinguished contribution to astronomy."

Dr. Ida Barney retired from Yale in 1955 but continued to work on new photographic zone catalogues. She died in 1982 at age ninety-five and was buried in Grove Street Cemetery. In 1994, 5655 Barney, an asteroid from the central regions of the main asteroid belt, was named for Ida Barney.

ANDREW JOHNSON

On June 27, 1867, Abraham Lincoln's successor, President Andrew Johnson, was welcomed to New Haven by its mayor and Connecticut governor James E. English. Accompanying the president was U.S. secretary of state William H. Seward, who only a little more than two years earlier had nearly been assassinated by one of the Lincoln assassination conspirators and less than three months earlier had negotiated the purchase of Alaska from Russia. Opponents would call it "Seward's Folly," but long after Seward's 1872 death, it would be considered one of the most important agreements in U.S. history.

President Johnson and Secretary of State Seward spent a great deal of time shaking the hands of well-wishers and an even longer time proceeding though New Haven streets. They concluded the day by addressing the students of Yale College.

In his remarks at New Haven, Seward noted that Connecticut was known for producing teachers and "for making a great many things." With the Civil War having ended two years earlier, Seward knew most of the Yale faculty and students supported the North, but he wanted to mend the division of the states. The southern states desperately needed aid, and Seward urged his audience into a new direction: to send the South "instead of soldiers—schoolmasters, teachers, ministers of the Gospel; do not forget to send them your artisans, your mechanics, as well as your philosophers."

THE VOYNICH MANUSCRIPT

In the bowels of Yale University's Beinecke Rare Book & Manuscript Library sits an approximately six-hundred-year-old book commonly called the Voynich Manuscript. Created somewhere in Central Europe by an unknown author, the 240-page volume is filled with curious colorful drawings and handwritten undeciphered words. The drawings appear to depict plants, medicinal herbs and roots, female nudes and astronomical and astrological themes.

Named after Polish American bookseller Wilfrid Voynich (1865–1930), who purchased it in 1912, the manuscript had been owned by Holy Roman Emperor Rudolph II (1576–1612), a Jesuit College near Rome and other collectors. It was donated to Beinecke Library in 1969 by a man who obtained it from the estate of Voynich's widow.

Voynich theorized that the manuscript might have been the work of one of two thirteenth-century Roman Catholic friars—Englishman Roger Bacon or German Albertus Magnus. However, later carbon-dating showed the pages to be from the early fifteenth century.

Throughout the twentieth and early twenty-first centuries, many attempts have been made to decode the manuscript's text, but none survived the objections of scholars, including experts in medieval history, linguistics and cryptography. The Voynich Manuscript remains a mystery.

HARRY S. TRUMAN

In 1958, five years after he left the White House, Harry S. Truman visited New Haven to speak at Yale under the Chubb Fellowship, which brings distinguished public figures to the university. Referring to political machines, Truman stated: "When you refer to a boss in your own party, he is a leader; when you refer to the machine in your own party, it's an organization." During the three days he was at Yale, Truman took his famous walk early each morning. One of the Yale students who accompanied the seventy-three-year-old former president commented: "When they say Mr. Truman takes a brisk walk, they mean it."

PRESIDENT THEODORE DWIGHT WOOLSEY

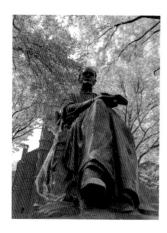

Theodore Dwight Woolsey became the tenth president of Yale University in 1846. This statue of him sits in a four-acre courtyard north of Connecticut Hall. *Authors' collection.*

When Theodore Dwight Woolsey became president of Yale College in 1846, few people were surprised. His uncle Timothy Dwight had been president of Yale for twenty-two years (1795–1817) and his cousin Timothy Dwight V would be president for thirteen years (1886–1899). Theodore would serve in the office for even longer: twenty-five years (1846–1871).

A story has been handed down at Yale that during his long tenure as president, Theodore Dwight Woolsey would often kick the first boat to start a Yale regatta, and when he did, the Yale men would win the race. Since then, according to one story, students rub the toe of Woolsey's 1896 seated statue on the Old Campus for good luck. Whether this is true or not, it's a fact that the protruding bronze foot is exceptionally shiny.

John Humphrey Noyes

One of Yale's most controversial graduates was John Humphrey Noyes. While a student at the school, Noyes developed the doctrine of "Perfectionism," whereby he believed people are totally free from sin when they are converted to Christianity. This differed dramatically from the traditional doctrines taught by the Christian churches. Yale College granted Noyes a license to preach in 1833 but revoked it, citing Noyes's radical religious teachings as the reason. So, John Noyes set off on his own to convince people of the truth of his doctrines.

In 1836, Noyes organized a group he called "Bible Communists," and a year later, he publicized his views on God's plan for sexual relations between men and women. For this, he coined the term "free love." His community abandoned traditional marriage for Noyes's "complex marriage," whereby all men of their community were married to all women. Almost all other Christians in America called it adultery.

When the Noyes community disbanded in the early 1880s, it wasn't because of financial difficulties—they were doing very well in that regard. More important was Noyes's introduction of his own version of eugenics. Named "stirpiculture" by him, it involved the selective breeding of community members to create an improved race. Noyes personally chose who would be allowed to have children, except for a period of fifteen months in 1875–76 when he tried assigning the decision to a committee of twelve elders. One of the most controversial aspects of Noyes's leadership, and probably the most self-serving, was his practice of being the first man to have intercourse with girls when they reached puberty. Some of these girls were only nine or ten years old. Whenever Noyes didn't perform the "task," he appointed one of his right-hand men to serve in his place.

In 1879, Noyes, under threat of arrest in New York State for statutory rape, fled to Niagara Falls, Canada. He lived there for the rest of his life in a comfortable house, where he frequently received visits by former members of his group who sought his advice. He died in 1886 at age seventy-four.

Honorary Yale Degrees

In June 1934, Franklin D. Roosevelt became the second U.S. president to receive an honorary Yale degree while attending commencement

ceremonies. After the ceremony, Roosevelt traveled on his yacht *Sequoia* to New London to see his son Franklin, who was on the Harvard freshman team in the Harvard-Yale regatta.

Eight other presidents have received honorary Yale degrees. Theodore Roosevelt received his in person in 1901. George Washington and William McKinley (1898) received their honorary degrees while in office, but they didn't attend the New Haven ceremonies. Thomas Jefferson, John Adams, William Howard Taft (1893), Woodrow Wilson (1901) and Herbert Hoover (1918) received their honorary degrees from Yale before they became president.

In 1910, Yale awarded an honorary degree to a woman for the first time. The recipient was pioneer American social worker Jane Addams. Addams was best known as the leading spokesperson for the "settlement movement"

American social worker Jane Addams (1860–1935) was the first woman to receive an honorary degree from Yale University. *Courtesy of the Library of Congress.*

in which middle-class workers would live in the same buildings or neighborhoods as low-income people and share their knowledge, experiences and culture. Jane Addams's Hull House in Chicago, Illinois, which housed recently arrived European immigrants, was the most famous of the settlement movement's homes. Addams also supported the women's suffrage movement and efforts to achieve world peace. In presenting Addams to Yale's president, Professor Bernadotte Perrin noted that she "has had a prophetic vision of what might be done, and militant courage, united with a high order of administrative, social, and political capacity, in doing and getting it done." Two decades after receiving her honorary degree in New Haven, Addams would receive the Nobel Peace Prize (1931).

NOBEL LAUREATES AT YALE

About seventy Yale University faculty, staff and students have received Nobel Prizes. Only a few Nobel laureates can be mentioned here. Those who received their degrees before 1970 include Sinclair Lewis (1885–1951) who received the 1930 Nobel Prize for Literature. In addition to graduating from Yale with a bachelor's degree, Lewis worked for Associated Press in New Haven.

The winners of the 1954 and 1958 Nobel Prizes in Physiology or Medicine were John F. Enders (1897–1985) and Joshua Lederberg (1925–2008), who received degrees from Yale—Enders a bachelor's degree in 1920 and Lederberg a PhD in 1947.

Nearly thirty full-time Yale University faculty members have received Nobel Prizes. Two of the earliest were Willis E. Lamb Jr. (1913–2008), who won the 1955 prize in physics, and Lars Onsager (1903–1976), who won the 1968 prize in chemistry.

After Onsager was appointed to the Yale faculty, it was revealed that he did not possess a doctorate. When he finally completed his dissertation, the Yale chemistry and physics departments had no one who was knowledgeable enough to understand it. It was only after the intervention of Yale's Mathematics Department that it was approved. Onsager served on the Yale faculty from 1934 until his retirement in 1972.

LINONIA

Linonia was a literary and debating society for Yale students. In the late 1700s, all Yale freshmen were enrolled in either Linonia or the Brothers in Unity debating society; the latter was founded fifteen years after Linonia. Considered one of Yale's secret societies, Linonia was more open in its membership, taking some of its members from Yale's graduate and professional schools, in addition to undergraduates in their senior years. Linonia and Brothers also differed from the other societies by holding debates and talks. Given the large number of new members each year, it's not surprising that many famous Yale graduates were members of Linonia. They include: Revolutionary War hero Nathan Hale (who became secretary and later president of the society), cotton gin inventor Eli Whitney, writer James Fenimore Cooper and President William Howard Taft.

In the early 1870s, both Linonia and the Brothers in Unity disbanded. Apparently, the societies were having trouble retaining member interest. Five years before they closed, an amendment to the Linonia constitution appeared in the *Yale Courant* newspaper, which said that any "Orator, Essayist or Disputant" who fails to show up for a debate and does not furnish a substitute would be fined one dollar. The same fine was levied against any president or vice president who similarly shirked his duties.

Monthly dues by its members had allowed Linonia's library to grow from 100 books in 1770 to 13,300 in 1870. The Brothers in Unity library was of similar size: 163 books in 1781 and 13,400 in 1870. Additionally, dues often went toward debate prizes and special projects such as the Plymouth, Massachusetts Pilgrims' Monument. Today, Sterling Memorial Library contains a Linonia and Brothers reading room, which includes the libraries of the two associations.

MORY'S

Mory's, a private club in the heart of the Yale University campus, is open to all Yale students, faculty, employees and alumni as well as others with an affiliation to Yale. Founded as a tavern in 1861 by former railway mechanic Frank "Mory" Moriarty (circa 1824–1876) and his wife, Jane (1820–1885), it became a restaurant and then a private club in 1912. Over the centuries, Mory's has moved around New Haven, starting at Wooster Street, moving to Court Street and then to Temple and Center before reaching its current location on York Street.

One tradition at Mory's is the carving of initials and other words into its dark wood tables. Another tradition involves the Yale Whiffenpoofs, an a cappella singing group made up of members of the university's senior class. Performing weekly at the establishment, their signature song is, appropriately, the "Whiffenpoof Song," which became famous in the twentieth century when it was recorded by top artists. Mory's was a men's club until 1972, when women were admitted; however, the first woman Whiffenpoof didn't appear until 2018.

Front door of Mory's, Yale University's most famous private club. In the background is the fourteen-story tower of the Hall of Graduate Studies. *Authors' collection.*

INDIANA JONES

Perhaps the most famous movie ever filmed in New Haven was 2007's *Indiana Jones and the Kingdom of the Crystal Skull*. Although only several minutes were shot on the Yale University campus, they were some of the most action-packed scenes in the film. Since it was set in 1957, vintage motor vehicles and period clothing needed to be brought onto the streets of New Haven. Interestingly, director Steven Spielberg's son was a student at Yale at the time the movie was filmed.

The main New Haven action involves archaeologist "Indiana" Jones (portrayed by Harrison Ford) escaping from KGB agents on a motorcycle driven by his son (played by Shia LaBeouf). The chase scene shows the pair racing through the Old Campus courtyard, the Sterling Library, the University Commons dining hall and the streets of New Haven.

Eighty-two years prior to the filming of the movie, motorcycles were in the news at Yale. In April 1925, the university prohibited them from being driven on campus. As related in a *New York Times* article at the time, both the facility and the students' council voted to bar the vehicles "after several near-sighted professors have been run down by reckless undergraduates who have used motorcycles to get from one recitation room to another." At the time, some people were proposing using a ride service that sounded much like today's Uber.

AFRICAN AMERICANS

New Haveners of African American descent have contributed to their city to a remarkable degree. A few of their stories are related here, while additional entries appear in other chapters.

THE *AMISTAD*

In 1839, slave hunters captured local people near present-day Sierra Leone, Africa, and transported them to Havana, Cuba. Plantation owners Don Jose Ruiz and Don Pedro Montez bought fifty-three of these people and set sail on their ship, the *Amistad*, to their plantations. While en route, one of the captives, Joseph Cinque, worked himself free of his bonds and released his fellow slaves. They killed the ship's captain and the cook. They demanded Ruiz and Montez sail back to Africa, but the two men instead sailed north and were taken by the U.S. ship *Washington* off Long Island, New York. Most of the enslaved Africans were charged with murder and piracy and jailed in New Haven. New York City's *Sun* newspaper published a print of their leader Cinque captioned "The brave Congolese Chief, who prefers death to Slavery, and who now lies in Jail in Irons at New Haven, Conn. awaiting his trial for daring for freedom."

Since 1807, it had been illegal to bring enslaved Africans into the United States, and both the District Court and the Circuit Court ruled that the

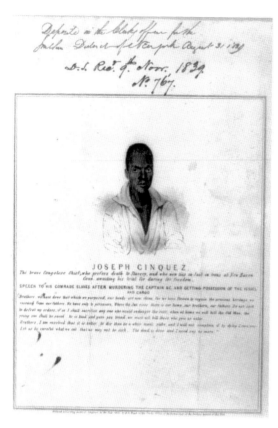

Left: *The Sun*, a New York newspaper, published this print of Cinque in 1839. *Courtesy of the Library of Congress.*

Below: Launched in March 2000, the *Freedom Schooner Amistad* is a replica of the nineteenth-century slave ship *Amistad*. *Courtesy New England Photo.*

African captives were not Spanish and should be allowed to return to Africa. In 1841, the case proceeded to the Supreme Court. Local abolitionists sponsoring the Africans' case enlisted seventy-two-year-old former president and secretary of state John Quincy Adams to argue their case before the Supreme Court. He did, and the justices decided 7–1 in the Africans' favor. The lone dissenting justice was New Haven native Henry Baldwin (1780– 1844). In November 1841, thirty-five surviving captives, including Joseph Cinque, returned to their homeland in Africa.

EDWARD BOUCHET, PHD

The first African American to receive a doctoral degree in the United States was Edward Alexander Bouchet. Born in New Haven on September 15, 1852, he was one of the first black men to graduate from Yale College, which he attended from 1870 to 1874. Two years after graduation, he completed his Yale dissertation in physics, titled "Measuring Refractive Indices." He was also elected to the Phi Beta Kappa honor society. When he received the PhD, fewer than twenty doctorates in physics had been awarded in the history of the United States.

Prior to Yale, Bouchet attended New Haven's Artisan Street Colored School, New Haven High School (1866–68), and the Hopkins School (1868– 70), where he was first in his class. After receiving his doctorate from Yale, Bouchet taught physics and chemistry for twenty-six years at Philadelphia's Institute for Colored Youth (Cheyney University of Pennsylvania). After leaving Pennsylvania, he taught in Virginia, Ohio and Texas. At the end of his life, he returned to his childhood home in New Haven, where he died in 1918 and was buried in Evergreen Cemetery.

REVEREND DR. MARTIN LUTHER KING JR. AT YALE

Like almost all universities, Yale awards honorary degrees at each June commencement. On June 15, 1964, thirteen people received honorary degrees at Yale, including American diplomat W. Averell Harriman, husband-and-wife show business legends Alfred Lunt and Lynn Fontanne and Peace Corps director Sargent Shriver. But there was only one recipient

that day who received a standing ovation from the two thousand graduates and ten thousand spectators—Dr. Martin Luther King Jr.

A *Hartford Courant* article observed: "There are not many people who can emerge from jail, and a few hours later obtain an honorary doctorate at Yale University." It was referring to the Reverend Dr. Martin Luther King, who, along with fellow civil rights leader the Reverend Ralph Abernathy, was released from a St. Johns County jail, where he was locked up for demanding service at a segregated St. Augustine, Florida restaurant.

In presenting King with an honorary doctor of laws degree, Yale president Kingman Brewster stated: "As your eloquence has kindled the nation's sense of outrage, so your steadfast refusal to countenance violence in resistance to injustice has heightened our sense of national shame." After the commencement activities, King held a short press conference in which he discussed his plans once the Civil Rights Bill of 1964 became law. Outlawing discrimination based on race, color, religion, sex or national origin, the bill was passed seventeen days later.

Constance Baker Motley

Constance Baker Motley was born in New Haven in 1921, the ninth of twelve children, to parents who were immigrants from the northern Caribbean island of Nevis. Her father, Willoughby Alva Baker, was a chef at Yale University, and her mother, Rachel Baker, was a founder of the New Haven chapter of the National Association for the Advancement of Colored People.

After graduating from Columbia Law School in 1946, Constance began two decades of service with the NAACP Legal Defense and Educational Fund, working to dismantle segregation throughout the United States. Motley ardently defended the right of protestors to march, sit-in and freedom ride; she fought for the right of African Americans to register and vote, sought and gained for blacks the right to attend formerly all-white schools and represented Dr. Martin Luther King Jr. and other civil rights activists when they were imprisoned in Southern jails.

At age thirty in 1951, Motley became the first African American woman to argue a case before the U.S. Supreme Court. She also was the only female member of the legal team that won the landmark desegregation case *Brown v. Board of Education* before the U.S. Supreme Court. As an attorney, Motley

New Haven–born Constance Baker Motley became the first black woman to serve as a federal judge. *Courtesy the Library of Congress.*

won nine of the ten major civil rights cases that she argued before the Supreme Court.

Journalist Charlayne Hunter-Gault wrote of Motley: "Mrs. Motley's style could be deceptive, often challenging a witness to get away with one lie after another without challenging them." But she would "suddenly throw a curve ball with so much skill and power that she would knock them off their chair."

In 1961, Motley was given the NAACP's New Haven Branch's Distinguished Service Award in a ceremony at Hillhouse High School, from which she graduated twenty-two years before. In her acceptance speech, she declared, "No award I've received so far in my career equals this, because it is given to me by my friends in New Haven."

In 1966, President Lyndon Johnson appointed Motley a judge on the United States District Court for the Southern District of New York, which was the largest federal trial court in the country. By this action, Motley became the first African American woman to serve as a federal judge. In 1982, she became chief judge of the court. Constance Baker Motley passed away in 2005 at age eighty-four.

7

RELIGION

In 1820, with a population of a little more than eight thousand residents, New Haven had seven churches, including the Yale College chapel. Two years later, the first Baptist church was built, and in 1834, the first Roman Catholic church opened. By 1855, with a population approaching thirty thousand, the city had twenty-seven churches and one synagogue.

Yale College was founded with a goal of training men for the ministry. In 1746, a professorship of divinity was established, and by 1822, it had evolved into a separate theology department. Subsequently, it became Yale Divinity School.

In 1835, Divinity College was constructed on Elm Street. In 1869, the building was torn down and replaced by Durfee Hall. A new Divinity School structure, designed by architect Richard Morris Hunt, was constructed across the street at the corner of Elm and College. East Divinity, as it was called, was built in 1869 and its adjoining Marquand Chapel was erected in 1871. In 1874, West Divinity was added to the left of Marquand Chapel. Trowbridge Library was squeezed in between West Divinity and Marquand in 1881.

Episcopal Church bishop John Williams founded the Berkeley Divinity School in 1854 in Middletown, Connecticut. It moved to New Haven in 1928, and in 1971, it became affiliated with Yale Divinity School.

In the early twentieth century, all Divinity School structures were demolished and replaced by Calhoun College, and a new Divinity School was constructed on the site of the Prospect Street mansion of Oliver Winchester, who had founded the nearby Winchester Repeating Arms Company.

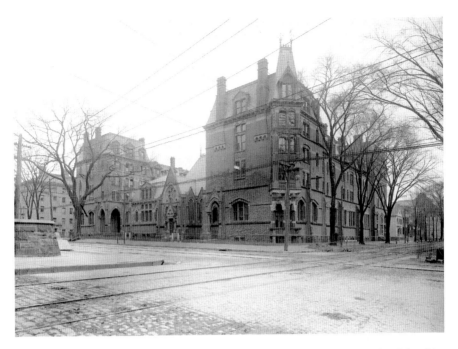

Yale Divinity School before it was razed to make room for Calhoun College. *From left to right*: West Divinity, the Marquand Chapel and East Divinity. *Courtesy Library of Congress, Prints and Photographs Division.*

TEMPLE MISHKAN ISRAEL

Although there were Jewish families in New Haven as early as 1772, the first congregation wasn't established until the early 1840s. First located on State Street, it moved to Court Street (from 1856 through 1896) and then to Orange Street (from 1896 through 1960). Today, the synagogue is located in the town of Hamden about two miles north of the New Haven city line. Temple Mishkan Israel is the oldest synagogue in Connecticut and the second-oldest in New England.

At the congregation's centennial, Yale's Sterling Memorial Library featured an exhibit detailing its history and displayed items covering Jewish life and literature. The main speaker at the opening ceremonies was Adolph S. Oko, a former scholar at the Hebrew Union College. (Oko's son became famous eight years later as captain of the ship SS *Kefalos*, which rescued thousands of Jewish refugees in the Balkans and brought them to the new nation of Israel.)

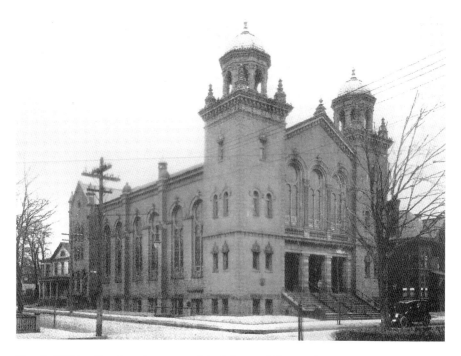

Temple Mishkan Israel on the corner of Audubon and Orange Streets. *From Everett G. Hill's 1918 book* A Modern History of New Haven and Eastern New Haven County.

One of Mishkan Israel's best-known rabbis was Edgar Siskin, who served as a Reform rabbi for forty-four years and had a simultaneous career as an anthropologist. In 1943, although he could have claimed a deferment because of his age (thirty-six) and his active service to the Mishkan Israel congregation, Siskin enlisted in the U.S. Navy. A *Chicago Tribune* article at the time of Siskin's death quotes a friend as saying, "He believed if ever there was a place for God, it was during war."

After World War II, Rabbi Siskin received a PhD in anthropology from Yale, served an Illinois congregation for twenty-four years and undertook a half a century of study of the Washoe Indians of Nevada and California. He died in 2001 at age ninety-four.

ST. MARY'S PARISH:
OLDEST CATHOLIC CHURCH IN NEW HAVEN

Founded in 1832, St. Mary's Parish is the oldest Catholic parish in New Haven and the second-oldest in the state. In addition to the New Haven church and its two hundred parishioners, St. Mary's first pastor, Father James McDermot, was responsible for all Catholics in the western part of the state, including Middletown, Waterbury and Bridgeport.

Christ's Church, the first permanent Catholic church in New Haven, was built on York Street in 1834. In 1848, the Congregational Meeting House building on Church Street was purchased and became New Haven's Catholic Church. Twenty-two years later, after New Haven's population was augmented by Irish immigrants, St. Mary's Parish purchased land in the upscale residential neighborhood on Hillhouse Avenue and construction began on a new, much larger church. It was finished in 1872 and dedicated on October 25, 1874.

Five years later, Father Patrick Lawlor was appointed pastor, and one of his assistant priests was Waterbury native Father Michael McGivney, who would become famous as the founder of the Knights of Columbus. In 1886, the Dominican Fathers were given responsibility for St. Mary's Parish, and in 1901, the Dominican order of Sisters of St. Mary's of the Springs established a convent and a school for grammar and high school students.

MICHAEL J. MCGIVNEY

After Father Michael J. McGivney, a son of Irish immigrants, was ordained a Roman Catholic priest on December 22, 1877, he was assigned to be assistant pastor at St. Mary's Church on Hillhouse Avenue in New Haven. A few years later, he founded the Knights of Columbus to help the widows and children of men who had died. A century and a half later, the Knights of Columbus is the largest Catholic fraternal benefit society in the world.

After seven years (1877–84) in New Haven, Father McGivney was transferred to St. Thomas Church in Thomaston, Connecticut. He died there in 1890 at age thirty-eight. Since 1982, his remains have rested in a tomb in New Haven's St. Mary's Church. In April 2008, Pope Benedict XVI declared him venerable, a step that can proceed to sainthood.

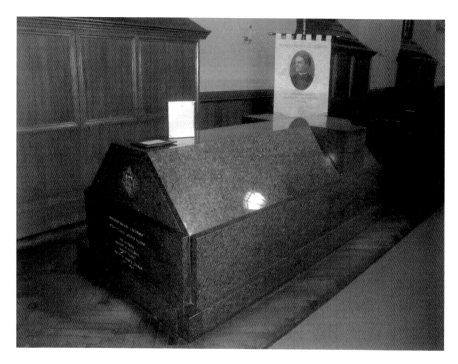

The tomb of Knights of Columbus founder Father Michael J. McGivney in St. Mary's Church on Hillhouse Avenue. *Authors' collection.*

Today, the Knights of Columbus, with headquarters in New Haven, has almost two million members. During Father McGivney's last eight years of life, fifty-seven Knights of Columbus councils were chartered. Today, that number has grown to over fifteen thousand councils in the United States, Canada, the Philippines, Mexico, Poland, Central America, the Caribbean, Lithuania, Ukraine and elsewhere. Each year, about $160 million and seventy million man-hours are donated to charitable causes by members of the order.

KNIGHTS OF COLUMBUS HEADQUARTERS

The year 1969 saw the opening of the twenty-three-story international headquarters of the largest Roman Catholic fraternal society, the Knights of Columbus, at the corner of Church Street and Frontage Road. With its four massive circular towers, at 321 feet high, it was the tallest building in

New Haven. Back when construction began in 1967, it took forty days and nights to pour the concrete for the towers and the central elevator well.

As of 2018, the Knights of Columbus headquarters building is the third-tallest in New Haven. Only the 383-foot-tall Connecticut Financial Center on Church Street (twenty-six stories, completed in 1990) and 360 State Street (thirty-one stories, completed in 2010) are taller. As a sign of rising costs, the 338-foot-high 360 State Street building cost $180 million to construct between 2008 and 2010, while the Knights of Columbus structure came in at less than $10 million when it was built between 1967 and 1969.

ST. THOMAS MORE CHAPEL

In the late 1930s, Yale Catholic alumni, faculty members and students financed the building of the St. Thomas More Chapel, which was named after the sixteenth-century English scholar, statesman and saint.

The chapel's history started sixteen years before its construction when the newly ordained priest, Thomas Lawrason Riggs, moved to the university's campus and lived there at his own expense while providing students with spiritual support. Before becoming a priest, Father Riggs was a 1910 Yale graduate and the co-writer of the comic opera *See America First* with his fellow classmate composer Cole Porter. It was the first of Porter's works to reach Broadway.

After serving during World War I, Riggs moved to Yale in 1922. At the time, less than 1 percent of Yale's student body (three hundred students) was Catholic. Fr. Riggs proceeded to say masses and establish a student Catholic club. Today, 29 percent of the Yale students who returned a religion survey identified themselves as Catholic.

Father Riggs wrote that the Catholic Yale students are more "citizens of the University rather than of the city" and "their esprit de corps needs to be utilized for religious purposes by enabling them to worship together, amid inspiring surroundings, and to hear sermons adapted to their special problems and outlook."

Father Riggs believed it was appropriate for a Catholic church and center on the grounds of a secular university to be named after Thomas More, who was a scholar, a writer (his *Utopia* is one of the most popular books ever written) and a statesman (Lord Chancellor of England). In addition, More was a martyr for his church—he refused to swear an oath

Yale University's St. Thomas More Chapel, seen here under construction in the 1938, was designed by Yale alumnus Douglas Orr. *Courtesy the St. Thomas More Chapel.*

that declared the king of England was the head of the Catholic Church in England. Since the opening of the church, the chapel to the right of the sanctuary has been dedicated to the Blessed Virgin Mary under her title Our Lady of Guadalupe.

After over twenty years of serving as chaplain to Yale's Catholic students, Father Riggs died in 1943. As it was the height of World War II, members of the armed services who had been Yale students and friends of Father Riggs obtained special furloughs to return to New Haven and serve as altar boys at his funeral mass. In the mass's homily, Father Riggs was remembered as a "teacher, author, translator, lecturer, and apostle of truth." Attending the mass were one hundred priests, over twenty nuns from the Hospital of St. Raphael and leaders of other faith traditions, including Reverend Dr. Oscar Maurer, pastor of New Haven's historic Center Church, and Rabbi Edgar Siskin of Temple Mishkan Israel.

One of Father Riggs's last wishes was to be buried on the grounds of St. Thomas More Chapel. However, the Connecticut legislature needed to pass a bill to permit this since Connecticut statutes prohibited burials within 350 feet of any place of residence. His body currently rests under a tabletop tomb in the courtyard on the chapel's grounds.

Today, the chapel and its adjacent Golden Center (named after Thomas E. Golden Jr. and designed by world-renowned architect César Pelli) are the main gathering points for Yale University's Catholic students.

A few blocks away from the St. Thomas More Chapel, in Yale University's Beinecke Library, sits the prayer book that Thomas More had with him during his imprisonment in the Tower of London. Inside its front cover, More wrote, "Liber quonda Thomae Mori militis in multus locus manu sua propria in scriptus," which translated is: "Book of Thomas More, knight, annotated in various places in my own hand." One of More's inscriptions within the volume reads: "Give me thy grace, good Lord, to set the world at nought." More was only to leave the Tower one more time—to walk up a hill behind the castle to the spot where he was executed.

8

BUSINESS

B usiness in New Haven has ranged from clock, carriage and firearms products of the nineteenth century to mechanical toys, hamburgers and pizzas of today. Here we touch on only a fraction of the city's manufacturing and service legacy.

THE *CONNECTICUT GAZETTE*

In 1755, Benjamin Franklin and publisher James Parker of New York established in New Haven the first newspaper to be published in Connecticut. The *Connecticut Gazette* specialized in reporting news of the French and Indian War (1754–63). Soon after the war ended, it was suspended, but it was restarted in 1765 by Franklin's nephew Benjamin Mecom. The newspaper was discontinued in 1768.

NINETEENTH-CENTURY OCCUPATIONS

New Haven business prospered at the beginning of the nineteenth century (1811) with fifty carpenters and joiners, forty-two grocery stores, forty-one dry goods stores, thirty shoe and boot makers, twenty-nine blacksmiths,

Newsboys ranging in age from seven to twenty-one stand on the New Haven Green in 1924. *Courtesy the Library of Congress.*

twenty-six tailors and twenty-nine businesses engaged in international commerce. The professions included sixteen lawyers, six clergymen, nine physicians and one surgeon.

In the remainder of the nineteenth century, the Industrial Revolution took hold in the city, and longtime residents, as well as new immigrants, filled the thousands of newly created manufacturing jobs. By the end of the century, New Haven was home to approximately seven hundred factories.

A 1901 Connecticut Bureau of Labor Statistics report listed 614 types of products manufactured in New Haven. These ranged from bicycle handlebars to automobiles, from fishing reels to cameras, from paper bags to iron bridges. The same report found the nearby town of Cheshire with only 14 types of manufactured items, while Hamden had 52.

The Whitneys

Eli Whitney is known world-wide as the inventor of the cotton gin, a machine that separates cotton fibers from their seeds, which greatly increased cotton production. Little known are the inventions of his nephews. After Eli's death, Eli Whitney Blake (1795–1886), Philos Blake (1791–1871) and John Blake set up a factory in the Westville section of New Haven to make door hardware.

Eli Whitney Blake became known throughout the nation for his invention of a stone-crushing machine, which played a significant role in the construction of roads in the United States, while his brother Philos concentrated on much smaller devices: a toothbrush for machinery (1830), a nutcracker (1853), an oyster knife (1854) and, perhaps most famously of all, the corkscrew (1860).

Other New Haven inventors were equally as practical. In 1823, G. Martin invented a manure fork; in 1830, R. Arnold received a patent for a washing machine; in 1852, Jonathan Turner invented an alarm clock; and in 1854, Levi Van Hoesen patented a piano stool. There are about 20,000 patents granted to Connecticut inventors, and a bit of hidden history is revealed when one learns that about 3,200 of these patents were awarded to New Haven inventors.

New Haven's Women Inventors

A number of New Haven women also patented their inventions. In 1871, patents were approved for Carrie Jessup's culinary vessel and Mary M.J. O'Sullivan's improved dinner plate covers. Evelyn Beecher invented an alarm device for money drawers (1879) and a rotary cutter (1887). In 1890, Mathilde Schott had two inventions patented—one for a surgical knife with a detachable blade and the other for a dice-throwing device.

Pianos and Corsets

Three Germany-born Jewish men who played important roles in New Haven's business and industry were Bernard Shoninger, Max Adler and Isaac Strouse. Adler and Strouse made corsets—in fact, they were responsible for

Left: On October 14, 1884, New Havener Leila C. Harrison received patent no. 306,484 for this hitching device. *Courtesy of the United States Patent and Trademark Office.*

Right: On May 9, 1911, William A. Bein of B. Shoninger & Co. received this patent. *Courtesy of the United States Patent and Trademark Office.*

New Haven becoming the leading corset manufacturer in the world in the late nineteenth century.

Bernard Shoninger immigrated to the United States in the 1840s, established his business in New Haven in 1865 and lived until 1910. His factory at the corner of Chapel and Chestnut Streets manufactured pianos and organs. An early twentieth-century advertisement headlined "Pianos, Melodeons [a type of small organ] & Organs" and mentioned they also carried "[v]iolins, guitars, accordeons [*sic*], flutinas [a type of accordion], concertinas, flutes, and fifes." Later, the shifting market resulted in the company changing its name from B. Shoninger Organ Company to B. Shoninger & Co. and, in the 1922, to the Shoninger Piano Company, as it then specialized in player pianos, upright pianos and grand pianos.

Pictured above is a drawing from patent no. 991,822 for an improved center panel for an upright player piano. It was awarded to William A. Bein,

who for twenty-five years was B. Shoninger & Co.'s general superintendent as well as an accomplished painter and carver. Bein died at St. Raphael's Hospital in 1943 at age eighty-five.

In the 1930s, the Shoninger Piano Company became part of National Piano Manufacturing, which used the Shoninger name for another three decades.

WORLD'S HIGHEST PAID BUSINESSWOMAN

Blanche Granville Green, who many believed was the highest-paid businesswoman in the world in the late 1920s. *Courtesy of Blanchard Granville.*

In 1912, unemployed Blanche Green moved to New Haven with her young daughter and her husband, who was permanently paralyzed as a result of being thrown from a horse. Twelve years later, after an incredible career, she was believed to be the highest-paid businesswoman in the world.

A farm woman with no employment history, Green applied for a job at corset manufacturer Berger Brothers Company, whose origins started with a one-room enterprise on Chapel Street and was just expanding its operations outside Connecticut. Although given a polite refusal letter, Green persevered, was accepted and quickly rose through the ranks: traveling throughout the country, opening branch offices, hiring sales and management personnel and developing employee training programs. Due largely to her efforts, the company's sales and profits skyrocketed. Green attributed her success to her organization and determination—to stretch herself to do more. Her motto to other women was "Plan your work and work your plan."

By 1927, Green was president and international sales manager for three to four thousand workers at the Berger Brothers Company and earned an annual salary of $100,000. When in 1937 the *New York Times* published its list of highest salaries of Americans for 1935, it featured industrialists, bankers, publishers, movie stars and others. By then, Blanche Green was president

of the Spencer Corset Company in New Haven and earned over $57,000. (Probably as a result of the Great Depression, President George Berger of her old company was earning less than Green had made ten years earlier—his 1935 salary was $95,000.) By comparison with Green's $57,000, Edsel Ford, president of Ford Motor Company, earned $100,000 that year, and actor Cary Grant, who was fast becoming one of Hollywood's most popular stars, made $52,000.

Even when earning the largest salary of any woman in America and spending most days of the year traveling around the United States and Europe, when Green returned home, she resumed her normal chores—caring for her paralyzed husband, her daughter and her in-laws and attending church regularly—as well as quietly founding a home for destitute young mothers and their children.

Today, Blanche Green is being recognized again by her great-nephew Blanchard Granville, who told the authors, "I've been wanting to write a book about her life. It would make a great rags-to-riches movie."

THE TAFT HOTEL

Over the years, the Taft Hotel played an important part in New Haven's history. A radio station broadcasted from the Taft, and many famous stage actors considered it their home while performing in New Haven.

On January 1, 1912, the Taft Hotel opened on the southeast corner of College and Chapel Streets. The site had been the location of taverns and hotels from the seventeenth through the twentieth century. The eighteenth-century Isaac Beers' tavern was visited by Washington, Lafayette and Rochambeau.

Although the Taft served as the residence of former U.S. president William Howard Taft during the years (1913–21) he taught at Yale, the hotel was originally named after his younger brother Horace Taft, headmaster of Watertown, Connecticut's Taft School and one of the hotel's major investors. At its opening, the twelve-story Taft Hotel featured 450 rooms. In addition to the lobby, stores and restaurants filled the first two floors, while a ballroom occupied another two floors.

Located next to the Shubert Theater (and connected to it by a tunnel), the Taft welcomed the top stars of the American stage. Rodgers and Hammerstein wrote most of *Oklahoma!* in their rooms in the Taft. Other

New Haven's Taft Hotel prior to 1919. *From Everett G. Hill's* A Modern History of New Haven and Eastern New Haven County.

guests included: Woodrow Wilson, Admiral Richard Byrd, Albert Einstein, Babe Ruth, Lou Gehrig, Bill Tilden and Jack Dempsey. When Ruth arrived at the Taft in 1932, about ten thousand children were waiting to greet him.

Three major movies featured the Taft. In one, Bette Davis's *All about Eve*, which won the Academy Award for Best Picture of 1950, the story's narrator states, "To the theater world, New Haven, Connecticut, is a short stretch of sidewalk between the Shubert Theatre and the Taft Hotel, surrounded by what looks very much like a small city." The other two big motion pictures were Yvonne De Carlo's *Death of a Scoundrel* (1956) and Natalie Wood's *Splendor in the Grass* (1961).

Faced with competition from other establishments, especially the newly constructed Sheraton Park Plaza Hotel, the Taft closed in 1973. In the early 1980s, the building was converted into apartments.

A.C. GILBERT COMPANY

In the first years of the twentieth century, Alfred Carlton (A.C.) Gilbert worked as an amateur magician. After several years as a top Yale athlete, he achieved success at the 1908 Olympic trials with a new pole vault world

record (12 feet, 7.75 inches). However, his biggest claim to fame was still to occur—as the inventor of the Erector Set. Marketed as "The World's Greatest Construction Toy for Boys," the little metal girders and wheels allowed the construction of many different objects, from Ferris wheels and bridges to elevators and trucks. In 1916, at age thirty, Gilbert changed the name of his New Haven factory (which also made magic kits) from Mystro Manufacturing Company to the A.C. Gilbert Company.

Soon the company made a line of highly successful children's toys and educational kits: chemistry sets, mineralogy sets and, beginning in 1938, electric model trains. Between the 1930s and 1970s, Gilbert's company was New Haven's largest employer, with about five thousand workers on its payroll. He died at age seventy-six in 1961.

One 1950s boy who made good use of his Erector Set was future American physicist Steven Chu. In his official Nobel Prize biography, Chu

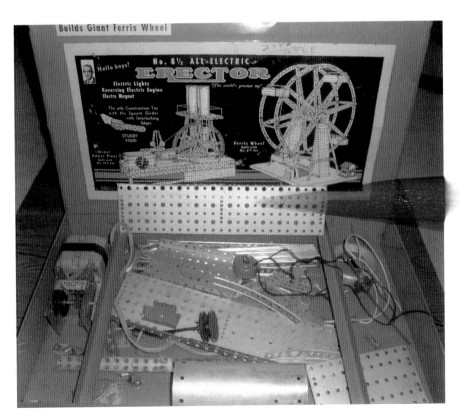

This A.C. Gilbert Erector Set model included all the parts necessary to build a motorized Ferris wheel, circa 1960. *Authors' collection.*

is quoted as saying, "By the fourth grade, I graduated to an erector set and spent many happy hours constructing devices of unknown purpose where the main design criterion was to maximize the number of moving parts and overall size. The living room rug was frequently littered with hundreds of metal 'girders' and tiny nuts and bolts surrounding half-finished structures."

In adulthood, Chu went on to win the 1997 Nobel Prize in Physics, and in 2009 he was appointed U.S. secretary of energy, becoming the first person appointed to a U.S. presidential cabinet after winning a Nobel Prize.

RADIO STATIONS

In 1921, the earliest radio station in Connecticut began with the call letters WCJ in New Haven. The station's owner was A.C. Gilbert Toy Company, and its radio license was the third in the United States.

That same year, New Haven–born Frank Doolittle (1893–1979) broadcast the first football game of Yale versus Princeton over his licensed amateur radio station, 1GAI. In 1922, he began Connecticut's first commercial broadcast station, WPAJ (AM). His experiments with two-channel broadcasting allowed him to broadcast over two different bandwidths, leading to stereo broadcasting.

In 1925, WPAJ became WDRC (Doolittle Radio Corporation). In the 1920s, it broadcast and transmitted from Taft Hotel. In October 1930, WDRC moved out of New Haven to Hartford, and today it is the oldest continuously running station in Connecticut.

THE WORLD'S FIRST TELEPHONE EXCHANGE

On April 27, 1877, Alexander Graham Bell presented a lecture at the Skiff Opera House in New Haven in which he proposed the idea of a commercial telephone exchange. It inspired George W. Coy, a disabled Civil War veteran and the manager of a telegraph office, to create world's first switchboard for commercial use. Coy and his partners set up the District Telephone Company of New Haven in 1878 in a storefront of the Boardman Building on Chapel Street in New Haven. Its switchboard could accommodate sixty-four customers but was limited to two simultaneous connections. A month

later, it published the world's first telephone directory—with fifty subscribers. As Coy's company grew, it changed its name to Connecticut Telephone and in 1882 became Southern New England Telephone. Coy stayed with the company until his death in 1915 at age seventy-eight.

The building where Coy started the first exchange was designated a National Historic Landmark in 1964, and a plaque was installed the following year. In 1968, the New Haven Redevelopment Agency purchased the site of the first telephone exchange and, five years later, demolished it to build a parking garage. The building is one of only thirty-five properties (less than 2 percent) since 1960 that have lost designation as National Historic Landmarks.

FIRST TELEPHONE BOOK

The first telephone book was published in New Haven on February 21, 1878, on one sheet of card stock. It included the names of ten private individuals, three physicians, two dentists, one minister (the pastor of the Church of the Redeemer), the New Haven Police Department and thirty-three businesses, all of which had telephones. As with all phone systems in the early years, personal interaction with an operator was required to make calls.

By the end of 1878, the New Haven listing had grown to about four hundred names, including twenty-two medical doctors, and it featured advertisements. In 2008, a November 1878 edition of the New Haven telephone book sold at auction at Sotheby's for $170,500.

NEW HAVEN FACTORY WORKER TO THE PRESIDENT OF THE WORLD'S LARGEST COMPANY

New Haven native James A. Farrell was president of United States Steel Corporation from 1911 to 1932. It was during his tenure that it became the country's first billion-dollar corporation. Born in 1863 in an average house on Chapel Street, Farrell was baptized at New Haven's St. Patrick's Church. His father, an Irish Catholic from Dublin, Ireland, was the captain and owner of several small ships that sailed between New Haven and Liverpool, England. Tragically, he was lost at sea when James was a teenager.

To help support his mother, sixteen-year-old James cut short his education and began working for the New Haven Wire Company on

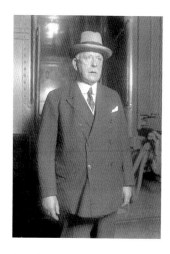

New Haven's James A. Farrell, pictured here circa 1920, became president of United States Steel Corporation. *From the* Los Angeles Times *photographic archive, UCLA Library.*

the Quinnipiac River as a wire puller. Asked many years later for the secrets of his success, Farrell said that when he started as a laborer he "studied very hard after finishing the whole round of the clock daily in the mill. I tried to learn all I could about the making of wire and I managed to qualify as a mechanic in a little over a year.... [A]lso, I had a fondness for selling things and I did my best to learn all about the duties of a salesman."

After nine years of manual labor in New Haven, he moved to New York to work for a steel spring manufacturing company. Within only a few years, he had moved into key positions in management and sales. Later, he moved up the ladder at U.S. Steel by concentrating on greatly expanding the company's export business.

Farrell was well known for his amazing memory. Once as a witness at a trial, he was asked facts about his industry, and he responded with such detail that one of the lawyers remarked, "That man's mind is a self-working cash register and adding machine combined."

When young Farrell had worked in New Haven, his twelve-hour workdays earned him eight cents per hour. Forty-nine years later, he visited the Wire Company plant in New Haven as company president. Farrell remembered his roots in the New Haven factory and could identify with the workingman's plight during the Great Depression when he stated it was "a pretty cheap sort of business when large steel and mining companies cut the hourly rate of men who are working only three days a week."

For his service to charitable causes, the pope named Farrell a Knight of the Order of St. Gregory the Great and the Order of Malta. When James A. Farrell died in 1943 at age eighty, he was still a member of U.S. Steel's Board of Directors.

LAW FIRMS

The law firm of Wiggin & Dana began on April 2, 1934, at 205 Church Street with seven members: partners Frederick Holme Wiggin (died at

age eighty-one in 1963), J. Dwight Dana (age sixty-two in 1951), Henry Stoddard, Huntington T. Day (age seventy-nine in 1981), Frank E. Callahan (age sixty-nine in 1968), Arnon D. Thomas (age sixty-eight in 1966) and law clerk Harrison F. Turnbull. In addition, John K. Beach was retained as counsel.

Henry Stoddard graduated from Albany Law School during the Civil War (1864) and was still working at Wiggin & Dana the year the United States entered World War II (1941). His career included service as a Connecticut Superior Court judge and thirty-five years as chief counsel of Yale University. In June 1939, the *American Bar Journal* recognized him as the oldest practicing lawyer in the United States. He was ninety-seven when he passed away.

By 1959, the firm had 14 partners and 4 associates. By 1984, on its fiftieth anniversary, it numbered 60 attorneys and in 2009 had 135 lawyers in five offices in three states. Many top lawyers began their careers at Wiggin & Dana, including longtime U.S. senator and 2000 Democratic vice presidential nominee Joe Lieberman. After receiving his LLB degree from Yale in 1967, he worked as an attorney for the firm before beginning his political career.

In 1995, Wiggin & Dana became a major sponsor of that year's Special Olympics World Games, which were held in New Haven. The firm's lawyers worked pro bono for three years. Later, partner Drake Turrentine left Wiggin & Dana to take the position of the chief legal officer of the Special Olympics. The firm's current location is at One Century Tower at 265 Church Street.

At the Special Olympics World Games in New Haven in 1995, over seven thousand athletes from 143 countries competed in twenty-one sports. *Courtesy New England Photo.*

ARCHITECTURAL FIRMS: CÉSAR PELLI

One of the most respected architects in the world is a longtime New Haven resident. César Pelli (1926–) is an Argentinian-born American architect who worked as project designer for the TWA Terminal at JFK Airport and Morse and Stiles Colleges at Yale University.

Pelli was a faculty member at the Yale School of Architecture from 1977 through 1984, including its dean from 1982 to 1984. While at Yale, he established his own architectural firm in New Haven, César Pelli and Associates, which was afterward renamed Pelli Clarke Pelli. César Pelli has said, "I always look forward to the next project. That is one of the wonderful things about architecture." And for him there have been nonstop projects—from the U.S. Embassy in Tokyo, Japan, to the Connecticut Science Center in Hartford, Connecticut, from the Landmark skyscraper in Abu Dhabi to the Eccles Theater in Salt Lake City, Utah.

In May 2008, Pelli received an honorary doctor of arts degree from Yale University.

His most famous works are the Petronas Towers in Kuala Lumpur, Malaysia, and the World Financial Center in New York City. From 1998 to 2004, the eighty-eight-floor Petronas Towers were the tallest buildings in the world. As of 2018, they are still the tallest twin towers in the world at 1,483 feet (452 meters).

LOLLIPOPS

Although a type of candy on a stick was popular before the twentieth century, it took George P. Smith, co-owner of the local Bradley Smith candy company in New Haven, to attach hard candy to a stick and make it popular. It was 1908, and he called them Lolly Pops, which was the name of a popular race horse. A year later, one of his employees, Max Buchmuller, received a patent on a machine to insert the candy onto sticks, and in 1931, the company received a trademark for the word "lollipop."

Although the company folded in the 1980s, lollipops found a permanent niche in American culture—from 1934, when child star Shirley Temple introduced her signature song "On the Good Ship Lollipop" in the movie *Bright Eyes* to the 1970s when Greek American actor Telly Savalas played the Tootsie Roll Pops–eating TV police detective Theo Kojak.

Today, lollipops continue to hold a top place as one of America's favorite candies, with National Lollipop Day celebrated every July 20.

CONNECTICUT'S MOST FAMOUS TV SPOKESMAN

New Haven's retail store founder and television spokesman Rueben "Rubie" Vine. *Courtesy Roberta Vine.*

One of New Haven's best-known businessmen was retail store founder Rueben "Rubie" Vine (1924–2011). Born in New Haven, Vine began his career selling *New Haven Register* newspapers at age nine. During World War II, he was wounded three times, captured by German forces at the Battle of the Bulge and held as a prisoner of war until the end of the war. For months, his family only knew that he was missing in action.

In 1950, many years before Ocean State Job Lot and the many dollar stores, Rubie founded the first Railroad Salvage discount store in New Haven. In later years, he expanded his business into a chain of successful stores extending across Connecticut and Massachusetts. His business was built on trust and a handshake.

Rubie's slogans included "bargains by the carload" and "if we can't sell it for less, we don't buy it." Part of the fun of shopping at Railroad Salvage was that customers never knew what bargains they might find on any given day. Its wide variety of merchandise included everything from clothing to surplus furniture, from cosmetics to construction materials.

As a businessman, Rubie Vine became a household name because of his exuberant personality and inventive television commercials. As a man, he was held in high esteem by his friends, employees, customers and, most of all, his family. Rubie's daughter told the authors that on her birthday she replays the voicemail that her father made the year before he died. In it, he wishes her a happy birthday.

NEW HAVEN–STYLE PIZZA

In 1925, Frank Pepe (1893–1969) established his pizza restaurant on New Haven's Wooster Street. After emigrating from Italy in 1909, he never left America except to fight for Italy during World War I. After the war, Pepe

started a bakery and delivered the product personally to his customers with carts.

In the mid-1920s, Pepe and his wife, Filomena, opened a pizza restaurant and fixed up the second story as their home. It featured thin-crust pizza baked in ovens that were similar to the pizzas of his birthplace near Naples, Italy. They offered two types of pizza—one topped with grated cheese, garlic, oregano and olive oil and the other with anchovies. Originally coke-fueled ovens, in the late 1960s, the ovens were converted to coal. Eventually, Pepe's type of pizza came to be known as "New Haven–style pizza."

In 1938, Pepe's nephew Salvatore Consiglio opened Sally's restaurant two blocks down Wooster Street and helped to make the street the pizza capital of New England. One lifelong resident of New Haven who knew Frank Sinatra told the authors that when the singer was in New York City, it was not uncommon for him to ask his limousine driver to drive up to New Haven's Wooster Street to pick up "eight or nine pizzas."

As the official Frank Pepe website states today, "Pizza has gone from an obscure ethnic dish to become a mainstay of the American dining scene." No one has been more instrumental in making that happen than Frank Pepe.

9

TRANSPORTATION

New Haven's location alone can account for much of its importance as a transportation hub. In colonial times, it served as one of New England's major seaports, and during the Industrial Revolution, it became a key train stop to and from New York City. In addition, New Haven carriage manufacturers dominated their industry for decades.

New Haven's importance to the history of transportation wasn't confined to travel over land and sea. The first submarine built and used for the military was David Bushnell's *Turtle*. He began his work on it in the early 1770s, while he was still a student at Yale College in New Haven.

At the beginning of the Great Depression, New Haven saw the opening of New Haven Municipal Airport (renamed Tweed–New Haven Municipal Airport thirty years later), and at the end of the Depression, construction began on Connecticut's first highway tunnel in the northern reaches of the city. Today, the Heroes' Tunnel remains the only highway tunnel in the state.

FARMINGTON CANAL

Early nineteenth-century New Haven businessmen came up with an ambitious plan for bringing wealth to New Haven by constructing an inland water route from New Haven to upper Massachusetts. Known as the Farmington Canal, as well as the New Haven and Northampton Canal, the construction began in 1825 and was completed by 1835.

In 1822, New Haven lawyer James Hillhouse met in Farmington, Connecticut, with representatives of seventeen towns to petition and receive a charter to the Farmington Canal Company. Erie Canal's chief engineer, Benjamin Wright, surveyed and submitted projected costs for the route: $420,696 from New Haven to the Massachusetts border plus the land cost. (By 1830, the canal's cost was estimated to be around $770,000.) Chief engineer Davis Hurd approved plans for the approximate eighty-five-mile canal route that included culverts, spillways and fills. It had a four-foot-deep trench—measuring thirty-four to thirty-six feet wide across the top and twenty feet along the bottom. Each side of the canal had at least a two-foot embankment to contain the water, with a berm bank of no less than five feet, next to which a ten-foot-wide towpath was made so horses and mules could pull the cargo-filled boats. Twenty-eight wooden locks were constructed so the canalboats could rise over two hundred feet from New Haven to Granby, Connecticut. Each lock was twelve feet wide and seventy-five feet long with a dry wall of heavy stone on the outer side supporting the canal. When the canal crossed rivers, wooden bridges or aqueducts were built.

It's hard to imagine with today's modern machinery that these nameless laborers hand-dug this canal with picks and shovels. They used wheelbarrows and horse-drawn wagons to haul away four million cubic yards of soil and rocks. Primarily Irish immigrants, they worked six or seven days a week, in ten-to-twenty-man crews, and slept in crowded boardinghouses after digging all day for forty cents. They sang of their ill-treatment: poor pay, late pay and company scrip pay—worth less than half of its stated value.

A new foreman was Gene McCanna
By God he was a blaming man
Last week a premature blast went off
A mile in the air went Big Jim Croft.
When next payday came around
Jim Croft was a dollar short. When he
Asked, "What for?" came the reply:
"You were docked for the time
You spent in the sky."

The groundbreaking ceremony was held in Granby on July 4, 1825, with an attendance of over two thousand people. Governor Oliver Wolcott Jr.'s shovel used to break ground broke—an ominous sign. You can see this

painted, ceremonial shovel—now mended—hanging on the wall at the New Haven Historical Society.

The high expectations on return investment didn't happen, as the company was plagued by financial problems. The Connecticut portion of the canal opened in October 1828, and *James Hillhouse*, the first commercial canalboat, was towed by four large, gray horses and traveled from New Haven to Simsbury with a cargo of sixty thousand shingles. Canalboats hauled molasses, oysters, salt, coffee, flour and coal north, while butter, cider, apples, maple sugar and wood traveled south. If a canalboat drawn by five horses traveled four miles per hour on a towline, a seventy-mile trip might take about twenty-four hours, with the passengers paying $3.75— including meals.

Businesses flourished along the canal's route, while other people enjoyed water recreation in the canal: boating, fishing or swimming during the summer and ice-skating in winter. Canalboats operated in the 1840s; by 1845, much of the canal service was closed, and by 1848, all commercial business ceased. The Farmington Canal Company recorded a profit for only one year—its overall loss was $1,377,156.54. The question remains, why didn't the state support this project—other states did—was it due to political pressure from Hartford's businessmen who didn't want this venture to succeed?

In 1847, the New Haven & Northampton Canal Company started constructing a rail bed alongside the canal. On January 11, 1848, steam-powered trains ran from New Haven to Plainville. In the 1980s, the Canal Railroad was severely damaged by floods and was totally abandoned. It was listed in the National Register of Historic Places in 1985 under the name Farmington Canal–New Haven–North Hampton Canal. From the 1990s to the present day, large tracts of the canals and rail beds were opened to the public as public walking and biking trails; they follow the original route from New Haven to Northampton.

HORSE TRANSPORTATION

In the days before motor vehicles, runaway horses posed an ever-present danger. In 1889, the *New Haven News* reported that Massachusetts schoolteacher Florence Caldwell on a visit to New Haven "gave an exhibition of courage by stopping a pair of runaway horses on State Street." She had spotted the horses break free of a hitching post and begin to gallop toward

her. "Calmly she stepped from the sidewalk," caught the rein of the nearest horse and stopped the team.

The following year, teamster Lew Woods was driving a pair of large horses down to Long Wharf when one of the bits broke. The pair galloped toward the water. Woods jumped off to safety, and the pair of horses dove ten feet into the water. One horse was crushed under the wagon, while the other surfaced and proceeded to swim across New Haven Harbor. Without stopping, it reached the eastern shore—a distance of a mile and a half. Immediately, witnesses wrapped the horse in warm blankets. Other than bruises over its eyes, the horse was uninjured.

The New Haven Railroad System

One of America's earliest railways was the Hartford & New Haven Railroad (H&NH), which was chartered in 1833. It connected Connecticut's co-capitals—until 1874, the Connecticut General Assembly met in May in Hartford and in October in New Haven. In 1844, the New York & New Haven (NY&NH) railroad was chartered to connect these two cities. Steam-powered trains also provided transport to the Quinnipiac River dock for steamship travel to New York, and trains connected New Haven to Plainville along the canal route in 1848. By 1849, the NY&NH was moving through Harlem and into eastern Manhattan.

By 1872, the New Haven Railroad (NHRR) had expanded and absorbed the NY&NH along with the H&NH. With its expansion, NHRR opened New Haven's Union Station in 1874. Its ambitious goal was to travel by rail from New York to Boston through New Haven.

In July 1907, New Haven Railroad sent its first electrified passenger train into New York. In 1909, the one hundred small, independent railroads that dotted southern New England over a sixty-year period became absorbed into one rail system. The New York, New Haven & Hartford (NYNH&H) line, often called the New Haven Railroad, transported people and cargo through Connecticut, Massachusetts, Rhode Island and eastern New York. New Haven electric trains, which used the pioneered AC (alternating current) transmission, proved to be a success over those that used DC (direct current). By the 1920s, it had over 2,000 miles of track throughout four states (New York, Connecticut, Massachusetts and Rhode Island) compared to its original 450 miles of track.

Today, Amtrak—traveling the northeast corridor from Washington, D.C., to Boston—considers New Haven to be one of its busiest stations, with a ridership of over 627,000 (2017), and the Metro-North Commuter Railroad's New Haven line has a ridership of 40.5 million annual rides (2016).

Union Station

The first Union Station was opened in 1848 by the New York & New Haven Railroad and was located east of downtown New Haven on Chapel Street. It was designed by Henry Austin (1804–1891) and cost about $40,000 to build. He placed a gallery over the rail lines. The noisy steam engine train platforms, located one floor below the lavish passenger waiting areas, were airless, sooty and uncomfortably cramped. However, Austin's exterior design was originally creative, as he incorporated different styles: an Italian villa style with a campanile—the first train station in America to incorporate this—a pagoda over its main entry, Moorish arches, a cupola, long horizontal lines interspersed with low roofs and extended flaring eves. One noteworthy creative architectural detail, soon copied by other train stations, was its ninety-foot-high clock tower with an eight-foot face, illuminated by gas, which could be seen from four directions. Twenty feet above the clock face was a bell that warned passengers of arriving and departing trains. This first Union Station was converted into a market in 1874 and destroyed by fire in 1894.

The consolidated New Haven Railroad deemed the first station to be outdated and crowded, so it paid $106,000 to erect an impressive three-story brick train station with dormer windows and a mansard roof, which were popular during the late nineteenth century. This second Union Station opened in 1874 and was constructed several blocks south of the first station on Meadow Street near the site of the current Union Station parking garage. This expansion required filling in wetlands for the rail yard.

New Haven's third Union Station was designed by American architect Cass Gilbert (1859–1934), who also designed the U.S. Supreme Court building in Washington, D.C., and the Ives Memorial Library in New Haven. It was completed in 1920 to serve as the main railroad passenger terminal for the New York, New Haven & Hartford line. The second depot caught fire and was razed soon after the new $900,000 station broke ground. The Beaux-Arts Union Station at 50 Union Street has little decoration on its

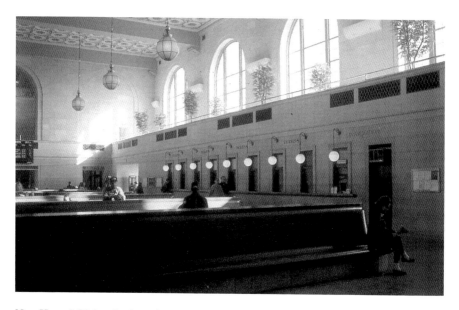

New Haven's Union Station, circa 1990s, was designed by the architect who designed the U.S. Supreme Court building in Washington, D.C. *Courtesy New England Photo.*

masonry covering the four-storied steel-frame structure; inside, natural light floods the large three-story center hall passenger waiting room. It is edged with massive three-story arches. Passengers descend to the lower level and through a tunnel to board or depart from trains.

In 1972, the Union Station building was closed and almost destroyed, although its platforms and underground access remained open. In 1975, it was placed in the National Register of Historic Places. After the efforts of Connecticut Department of Transportation (DOT) and the federal government funding of its Northeast Corridor Improvement Project, Union Station was renovated and reopened in 1985.

NEW HAVEN LIGHTHOUSES

Two lighthouses are located in today's New Haven Harbor: the seventy-foot-high Five Mile Point lighthouse on the mainland at Lighthouse Point Park (built in 1847) and the forty-five-foot-high cast-iron Southwest Ledge Light (opened in 1877), which is situated on a reef at the entrance to the harbor.

The inactive Five Mile Point lighthouse sits next to a two-and-a-half-story red brick keeper's house and is owned by the City of New Haven.

The Southwest Ledge Light is a little over a mile southwest of the Five Mile Point structure and includes a two-story lighthouse keeper's living quarters. Automated in the 1970s, it's an active lighthouse owned by Beacon Preservation, a nonprofit organization dedicated to the preservation of lighthouses. It is still managed by the U.S. Coast Guard. Over the decades, many lives have been saved by Southwest Ledge's keepers. For example, in the 1800s, assistant keeper Sidney Thompson saved the lives of four people, and in 1921, keeper Albert Wilkinson and his assistant J. Eliot Duley rescued two adults and a child in a rowboat.

MUTINIES

On June 25, 1890, U.S. Marshal Lovejoy made an uncommon arrest. The captain of a ship just outside the New Haven breakwater had complained that sailors on his vessel were unruly and on the verge of mutinying. His ship, the *Enigma*, had left New York City a day earlier bound for the West Indies. After Captain Dodd and his pilot Bayles came ashore to make out a complaint, Marshal Lovejoy took two assistants out to the vessel on a tugboat. They arrested, brought ashore and jailed three members of the crew, who were described as a "hard looking" lot who showed signs of "recent dissipation." After a hearing before U.S. commissioner W.A. Wright, the men were held in jail until the August term of the federal court.

Three years later, Commissioner Wright presided over a similar hearing. On Monday, October 2, 1893, two sailors on the schooner *Valentine*, which had just arrived from Philadelphia, were arrested in New Haven Harbor on a charge of mutiny. James Williams, Birkin Abrahamson and Christopher Faragren were taken by the U.S. marshal to Wright. The vessel's captain, S.C. Thompson, testified that the men "refused to obey orders." Since they could not make the bonds, they were sent to jail.

Five months later, another revolt played out again in New Haven Harbor. On March 8, 1894, the crew of the three-masted schooner *Elias Moore* arrived in New Haven Harbor with a load of lumber from Virginia. The captain paid off the crew, but two men would not accept the amount offered. They left the vessel, walked into New Haven—where they got drunk—and returned to the ship, demanding they be paid the amount they wanted or

they would sink the vessel and kill the captain. The police were called, but by the time they arrived at the dock, the two crew members had already broken into the cabin and escaped.

HEROES' TUNNEL

Construction of the limited-access Wilbur Cross Parkway began in 1939 and was completed in 1949. It was named for Wilbur Cross (1862–1948), who was governor of Connecticut throughout most of the 1930s. The parkway extends from the north end of the Merritt Parkway at the Milford/Stratford Sikorsky Bridge and terminates in the city of Meriden. Besides Milford and Meriden, it passes through Orange, New Haven, Hamden, North Haven and Wallingford. The New Haven segment includes the only highway tunnel to pass beneath a natural land formation in the state of Connecticut—the 1,200-foot-long twin-tube Heroes' Tunnel. (Before 2003, it was called the West Rock Tunnel.) Each tunnel tube is 28 feet wide and can accommodate two lanes of traffic. Over 100,000 cubic feet of dirt and stone needed to be excavated before the two tubes were constructed.

In the 1930s, the state decided to create the tunnel rather than simply cut out a slice of the trap rock ridge because West Rock Park, which is directly over that section of the mountain, would have been destroyed. Routing the parkway to the north would have extended the road too much, and a swing-around to the south would have gone through a densely populated section of New Haven. In addition to the engineering difficulties of creating the tunnel, its builders needed to contend with lawsuits brought by local residents who were inconvenienced by the explosions and the noise of construction equipment.

The $2.5 million tunnel opened to traffic on November 1, 1949. At that time, the state highway department engineers estimated that the tunnel and the seven-and-a-half-mile section of the parkway surrounding it reduced the average travel time from the twenty to thirty minutes it took to travel the alternate Routes 34/10 route to only eight to ten minutes.

At the opening ceremonies, Connecticut governor Chester Bowles called the tunnel a masterpiece of engineering that had subdued a hill "with rock as hard as flint." During the opening credits of the 1958 romantic comedy movie *The Tunnel of Love*, Doris Day and Richard Widmark drive through the westbound tube of the tunnel in a 1955 Ford Sunliner convertible as Doris sings the title song in the background.

PEARL HARBOR MEMORIAL BRIDGE

New Haven's major bridge, the Pearl Harbor Memorial Bridge, extends over the Quinnipiac River. It replaced the Quinnipiac River Bridge, nicknamed the Q-Bridge, which was constructed in 1958 as part of the new Connecticut Turnpike section of Interstate 95. The Pearl Harbor Memorial Bridge was built between 2012 and 2015 at a cost of $500 million. At its dedication in 2012, 250 navy veterans attended the ceremonies, while four of Connecticut's six surviving Pearl Harbor veterans participated in a wreath-laying ceremony.

AIRPORTS

For the location of the municipal airport, New Haven leaders chose a 110-acre site on the border with East Haven. Before the four grassy runways (each between 2,300 and 3,000 feet long) could be built, sixteen thousand trees had to be removed and an incredible amount of fill used to build up the site, since 30 percent of it was below sea level. It was estimated that the volume of fill would have filled a line of five-ton trucks extending from New Haven to Chicago, Illinois. In addition, over twelve miles of drainage pipe was installed underground.

On August 29, 1931, New Haven Municipal Airport officially opened with flying demonstrations by more than one hundred airplanes. The 9:00 a.m. to 8:00 p.m. activities included a model airplane contest, army and navy formation flying, a "bomb" dropping contest and a parachute jump. Thousands of attendees witnessed a near tragedy when two planes flown by Branford men collided in midair. Fortunately, both pilots were able to land without injury.

The airport was renamed Tweed–New Haven Municipal Airport in 1961. Its namesake was John Hancock "Jack" Tweed, the third person to obtain a pilot's license in Connecticut, a former navy flier, a stuntman and a test pilot. During over five thousand miles flown, Tweed crashed three times without serious injuries. By 1961, Tweed had managed the airport for its entire thirty-year existence, except for two and a half years during World War II when the army took over control. Five weeks after he was honored with the airport naming, Tweed died at age sixty-six. He was the grandson of "Boss" Tweed (1823–1878), the politician who had run the Tammany Hall political machine in New York.

CRIME AND CRIMINALS

N ot surprisingly, like all major cities, New Haven has had its share of criminals and criminal acts. We touch upon a few of them in this chapter.

EAST ROCK KILLINGS

Ireland-born transient James McCaffrey showed up in New Haven one day in 1849. He was described in a *Hartford Courant* article as "broad shouldered, and bandy legged, with bushy eyebrows, and a villainous expression of countenance."

McCaffrey befriended an elderly couple, Charles and Ann Smith, who were the longtime owners of a café on top of East Rock. McCaffrey expressed an interest in purchasing the business, and the last day Charles Smith was seen alive, he was heading home with McCaffrey.

Days later, the mutilated bodies of the Smiths were found near their business. Apparently, McCaffrey had murdered Charles, and when Ann heard her dying husband's cries, she ran over, only to be murdered herself by being shot through the heart by McCaffrey. McCaffrey quickly left town; however, the authorities found a bullet mold among his belongs that fit a bullet taken from Mrs. Smith's body. McCaffrey reached Canada, but he was tracked down and returned to New Haven for trial.

Arrested for the murder of Ann Smith, McCaffrey was tried and convicted in New Haven. The presiding judge, Samuel Church (1785–1854), stated: "That pistol ball which you sent to the heart of Mrs. Smith was lodged there to bear a dreadful testimony against you."

On October 2, 1850 at the New Haven jail, both McCaffrey and another convicted murderer were each dressed in white caps and robes; straps with buckles were used to tie each man's arms behind them at the elbows. McCaffrey was accompanied to the scaffold by a Catholic priest, the other felon by an Episcopal minister. With about two or three hundred ticket holders watching, the two prisoners were hanged at 10:57 a.m.

NEW HAVEN GALLOWS

Built in New Haven in the late 1870s, the New Haven gallows was used to execute seven men over a fifteen-year period. The gallows was first put into action in 1880 for the execution of Edwin Hoyt in Bridgeport. It was then trucked around Connecticut to help local sheriffs with their executions, each time being returned to New Haven for storage.

The grim list of its executions includes: Henry Hamlin in Hartford; James "Chip" Smith (who murdered Ansonia's chief of police) in New Haven; Philip Pallidonio in Bridgeport on October 5, 1888; John D. Swift in Hartford on May 18, 1889; and Jacob Schele (who killed a constable) in Bridgeport on June 18, 1891. It was last used in the execution in Litchfield of Milford killer Andrew Bolgensen in 1892. On that occasion, the pieces of the gallows were packed on a two-horse hay wagon for the forty-mile-long trip from New Haven. The authorities were careful to hide the weights and ropes under a large sailcloth so that they would not be visible to people along the route. However, the four posts and the steps were left in plain sight. After arrival, the gallows was assembled in the rear of the Litchfield jail with a barrier of wood and canvas twenty-five feet high to block the onlookers' view.

In 1894, the New Haven gallows was permanently retired, as a new law required all executions to occur at the state prison.

FIRST CONNECTICUT EXECUTION

The first recorded execution in Connecticut was of a Native American named Nepauduck in 1639. Since his hanging on the New Haven Green, thirty-eight people have been sentenced to death in New Haven. They include four other Native Americans, two African Americans and thirty-two Caucasians.

Until 1936, all Connecticut executions were carried out by hanging. The last person to receive that punishment was thirty-year-old John Simborski. He had killed fifty-three-year-old New Haven police officer Walter Koella in a gunfight near Sherman Avenue.

Patrolman Koella and his partner J. Kelly were chasing suspected burglar Simborski when the latter pulled a pistol from a shoulder holster and shot Koella twice—in the heart and in a lung. Patrolman Kelly felled Simborski with a bullet in the leg. Before Koella died, he identified Simborski as the man who shot him. This twenty-year veteran of the New Haven Police force, who lived with his wife and two children on Stanley Street, died at St. Raphael's Hospital despite the determined efforts of a team of doctors to save him.

John Simborski was found to have a criminal record that started at age eleven and included twenty-four arrests, stints at two reformatories and time in the Wethersfield State Prison. His attorneys unsuccessfully tried to argue that he should not be executed because the state legislature had recently changed the method of death from hanging to electrocution. Simborski was hanged on April 7, 1936, at the Wethersfield State Prison.

The next Connecticut execution employed the new method of electrocution. Forty-five-year-old steamfitter and Canadian World War I veteran James McElroy was convicted in New Haven of murdering his estranged mistress, New Haven Hospital nurse Anna Mae Johnson. While Johnson was with co-workers at the nearby Savin Rock amusement park, McElroy snuck into her apartment building and hid in a janitor's closet. When Johnson returned home and was walking up to her apartment, McElroy sprung on her with a razor and a knife. After nearly beheading her, he threw her body down the stairs.

At the trial, McElroy's public defender, Thomas Robinson, argued his client was "wild with jealousy" and was "no more responsible for his act than you or I would be in a similar case." The jury agreed more with state's attorney Samuel Hoyt, who stated, "This is an absolutely perfect case of first degree murder." McElroy was electrocuted at the Wethersfield prison on February 10, 1937. After that, all Connecticut executions were carried out with the electric chair.

NEW HAVEN'S WHIPPING POST

In colonial Connecticut, corporal punishment was common—both in the military and in civilian life. Whipping posts, public stocks, dunking and branding were some of the means by which criminals were punished. New Haven's whipping post stood a little northeast of Trinity Church on the New Haven Green. Shortly before the post was torn down in 1831, Constable Elihu Munson was given the task of whipping a poor man who was convicted of stealing a suit of clothes. It is said that he laid on the lashes "very lightly," and after the required number of strokes, the constable took up a collection from the crowd. He used the money to buy the stolen clothes from their owner and presented them to the thief.

TOWNSEND BANK ROBBERY

On May 22, 1865, New Haven was the site of one of the major bank robberies of the century. Townsend Savings Bank, located on the second floor of 111–13 Chapel Street (later renumbered 793 Chapel Street) was robbed of $100,000—which is the equivalent of about $1.5 million today. The perpetrator was assistant cashier Jeremiah Townsend, who lived on Martin Street (now part of West Haven). He was a distant relative of some of the bank's managers. Asking to stay late to finish up his work, Townsend used stolen keys, along with the combination he obtained from one of the head clerks, to unlock the bank's iron safe and removed money, bonds and notes.

Townsend fled to New York City, where he shaved his whiskers and disguised himself as a disabled military officer. From there, he went to Baltimore, donned a different disguise and traveled to Virginia and Pittsburgh, Pennsylvania. Then, Townsend took a steamboat down the Mississippi River. On the boat, a man named Ryan informed him of a robbery attempt that would be made on him. Grateful, Townsend invited Ryan to travel with him and Townsend's fiancée to England.

It wasn't until June 16 that authorities identified the robber. Townsend had given Ryan a note for $5,000 to exchange for gold in Philadelphia and instructions to give the coins to Townsend's fiancée in New Haven. He was to tell her to meet Townsend on the Caribbean island of St. Thomas (then owned by Denmark). From there, they would sail to Liverpool, England,

where they would be married. However, Ryan raised the suspicions of Philadelphia detectives, and they learned of Townsend's plans.

Unknown to Townsend, he was followed to England by two men from the Philadelphia police force, Detective Callahan and Detective Carlin, who were accompanied by one of the bank's directors, a Dr. Townsend, who was a distant relative of the robber and who presumably could identify him. When they confronted the fugitive cashier in Liverpool, he was quickly disarmed and found to have $42,000 on his person and $56,000 in gold in his luggage. Eventually, 99 percent of the stolen funds were recovered. In September 1865, Townsend was sentenced to seven years in the State Prison of Connecticut.

Although the bank recovered the stolen money, its future wasn't much brighter than Jeremiah Townsend's. It failed nine years later. Before the Great Depression of the 1930s, New Haven only had two other bank failures in its 135 years of banking history: the Eagle Bank and the Savings Bank of New Haven, both in 1825. On February 1, 1886, twelve years after Townsend Savings Bank's demise, the last of the bank's notes and stocks were sold for less than $500. Their face value was over $500,000.

NEW HAVEN POLICE DEPARTMENT

As one of New England's largest cities, New Haven has always maintained a world-class police force. A century ago (1918), the force numbered 270 professionals. The chief's office at the 165 Court Street headquarters also housed the chief's clerk, a stenographer, four police surgeons and four other employees. The same building housed the Detective Bureau (six members), Bureau of Identification (two members) and Station No. 1 (a captain, a desk sergeant, six sergeants, four court officers, two doormen, four chauffeurs and sixty-five patrolmen).

Three other police stations were spread around the city: Station 2 on the corner of Grand Avenue and Railroad Avenue (sixty-eight employees, including fifty-six patrolmen and three "motorcycle men"); Station 3 on the corner of Howard Avenue and Minor Street (forty-two employees, including thirty-three patrolmen and two motorcycle men); and Station 4 on the corner of Dixwell Avenue and Webster Street (fifty-two employees, including forty-four patrolmen and one motorcycle man).

In 1919, the New Haven Police Department arrest statistics were broken down by race and nationality. In addition to native-born white and black

Americans, it listed twenty-nine other places of birth in North America, South America, Europe, Asia and the Middle East.

The forty-four categories of felonies in 1919 included the common categories of burglaries (71) and thefts (252), to the very specific "breaking and entering freight car" and "embezzlement by bailee." The 126 misdemeanors categories included: "violation city ordinance de spitting," "violation statute de butter" and "concealment of birth of a bastard."

Gambling seems to have been a frequent problem, with these offenses: "betting on race horses," "keeping gaming house," "frequenting gaming house," and "gaming." The proliferation of automobiles in 1919 New Haven is seen by the fact that 20 percent of misdemeanor categories involved traffic offenses (24 of 126), although some of these may have been applicable to horse-drawn vehicles as well. In total, there were 678 felony arrests in New Haven in 1919, and 8,674 people were charged with misdemeanors.

The adoption of modern law enforcement methods and procedures was evident during the calendar year 1919: 250 photographs were taken of arrested persons, 770 fingerprints were filed and 250 Bertillon cards were filled out. After being introduced in France, these cards were adopted in the rest of Europe and the United Sates. They displayed a person's full face and profile photographs, as well as their name, measurements, scars, tattoos and so forth.

In the twentieth century, the New Haven Police Department advertised and recruited female officers. An area newspaper reported one of the first female officers, Brendella (Kitty) Coleman-Lokites, was hired in June 1974. She was a patrol officer who first walked her beat on Whaley Avenue and became the only female in the department's intelligence unit, and in 1984, she served as a police instructor and counselor at New Haven's training academy.

In the 1970s, the New Haven Police Department recruited Hattie Turner as a civilian employee in its Youth Division. This well-respected African American woman touched the lives of many of New Haven's youth on a concrete level; her career ended as a juvenile screener. She believed she could make a difference and had innovative ideas. She brought a wealth of experience to the department: her knowledge of the community, her outreach work in meeting many families one-on-one, her sensitivity in working with the Yale–New Haven Hospital Child Abuse Program with neglected or abused children, her wisdom in providing an African American Santa Claus when handing out 1,500 toys and her work with the Girl Scouts, United Way boards and the Mental Health Council. Hattie Turner passed away in 2013 at age eighty-nine.

HOLOCAUST MEMORIAL

New Haven remembers not only offenses committed locally but also national and even international crimes. One of the most notorious episodes of the latter is marked by a memorial on the corner of Whalley and West Park Avenues.

Built in 1977 at Edgewood Park, New Haven's Holocaust Memorial was the first Holocaust memorial in the United States to be constructed on public property. Created with funding and support of Holocaust survivors, the children of survivors and community leaders, it serves as a location of memorial services by the local Jewish community. It also is a permanent reminder for all people of the atrocities committed during Nazi Germany's Holocaust.

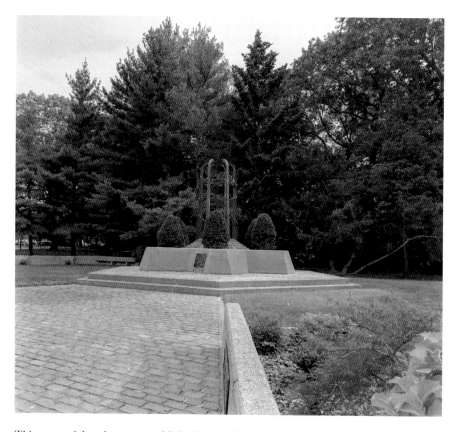

This memorial at the corner of Whalley and West Park Avenues serves as a reminder of the six million Jewish men, women and children who were murdered by the Nazis. *Authors' collection.*

Sitting on a base shaped like a Star of David, the memorial consists of six curved upright bars wrapped in barbed wire to represent the Nazi death camps. An attached plaque states, "We remember the six million Jews who were murdered by the Nazis during World War II 1939–1945 (5699–5705 [Hebrew calendar]). Dedicated by The City of New Haven [and] The New Haven Jewish Federation." A box containing ashes collected from the Auschwitz death camp is interred at the center of the memorial.

Plaques on surrounding walls are dedicated to the memory of "all innocent people who perished at the hands of the Nazis" and "to all the righteous gentiles who risked their lives to rescue Jews during the holocaust."

At the time of the memorial's construction, there were about two hundred Holocaust survivors living in the New Haven area.

11

ENTERTAINMENT

N ew Haven has long provided a home for numerous entertainment enterprises. Its modern entertainment industry took off in earnest in the 1890s when Italian immigrant Sylvester Poli opened his combination wax museum and vaudeville house. A couple of decades later, the Shubert brothers would establish the New Haven Shubert Theater, which would attract hundreds of top-notch performers.

New Haven's home-grown talent includes big band leader Artie Shaw, song-and-dance man turned politician George Murphy and Academy Award–winning actor Ernest Borgnine. In addition, actress Sigourney Weaver and *Monk*'s Tony Shalhoub learned their craft in New Haven as Yale students.

SYLVESTER POLI

In 1858, Sylvester Poli was born in a village northwest of Florence, Italy, and at age twenty-two, he immigrated to the United States. In the late nineteenth and early twentieth centuries, he became one of the major theater owners in his adopted country.

Poli began working as a wax sculptor in France while still a teenager. After moving to the United States, he continued his work as a modeler at Philadelphia's Egyptian Museum. His theater career took off in 1892,

when he opened Poli Eden Musee New Haven with four or five wax figures and a few vaudeville acts—acts sometimes performed six to ten times per day. Between the year 1893, when he established Poli's Wonderland Theatre in New Haven, and 1926, when Poli's Palace premiered in Worcester, Massachusetts, Poli built many theaters throughout the cities of the northeastern United States. He employed up to three thousand people and owned theaters with a combined total of about forty-five thousand seats. It has been said that at one time he personally owned more theaters than anyone else in the world.

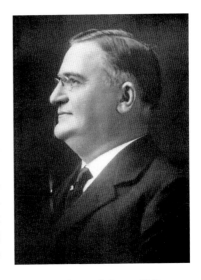

Italian immigrant Sylvester Poli assembled the largest chain of theaters in the world owned by one individual. *National Vaudeville Association.*

One writer in 1909 described Poli as "an easy going Italian, jolly, good natured, yet shrewd and a keen businessman— perhaps, with the exception of Meyerfeld [Morris Meyerfeld (1855–1935), who dominated vaudeville in the western United States for almost twenty years], the best businessman of them all and certainly one of the best showmen in the proper sense of that term."

In 1928, Poli sold his chain of twenty theaters to Fox Film Corporation founder William Fox for approximately $30 million. At the time, he told a *New York Times* reporter, "The old sculpture tools with which I made images in Italy, in Paris, and in New Haven forty or fifty years ago are still up in my attic. So is my fish pole....I really do not know which I shall bring down first." Poli retired to his estate in Milford, from which he traveled to New Haven to attend movies and plays. He passed away in 1937.

NEW HAVEN SHUBERT THEATRE

At the end of the 1890s, brothers Sam, Lee and J.J. Shubert, sons of Lithuanian Jewish parents, began what would become the United States' largest theater empire. After operating several theaters in upper New York State, they branched out to New York City in 1900 and New Haven in 1914.

Backstage at New Haven's Shubert Theatre on College Street. In its century of existence, no other theater has become better known for hosting pre-Broadway productions. *Authors' collection.*

When the New Haven theater opened with 1,820 seats, it was the largest theater in Connecticut.

Over the decades, the New Haven Shubert earned a reputation as a choice venue for shows scheduled to open on Broadway. In its history, it has hosted six hundred productions before they opened on Broadway, including over three hundred world premieres. Fittingly, it advertised itself as the "Birthplace of the Nation's Greatest Hits." One composer who chose to try out his productions at New Haven Shubert was Richard Rodgers. He arranged for it to host the world premieres of *South Pacific*, *The King and I*, *The Sound of Music* and eight of his other shows.

Over the years, the New Haven Shubert has hosted a fabulous array of stage and movie legends, including Sarah Bernhardt, Will Rogers, W.C. Fields, Ethel, John and Lionel Barrymore, George M. Cohan, Eddie Cantor and the Marx Brothers. The Shubert's history is almost the history of U.S. theater itself.

LONG WHARF THEATRE

Using warehouse space at the New Haven Food Terminal and seats from a defunct movie theater, Long Wharf Theatre was founded by Yale graduates Jon Jory (its artistic director and the son of famous character actor Victor Jory) and Harlan Kleiman (who handled the business end of the new venture).

In 1965, Long Wharf Theatre opened with thirteen performances of Arthur Miller's *The Crucible* and has since gone on to become one of the premier regional theaters of the Northeast.

In 2000, actress Michele Massa was in the cast of Long Wharf's *The Good Person of New Haven*, which ran for forty-eight performances. She remembers Long Wharf as "one of the best theaters in the country at that time. The people who ran it made it fun for everyone."

ARTIE SHAW

Born Arthur Arshawsky in 1910, clarinetist Artie Shaw led one of the most popular big bands of the 1930s and 1940s. He became known as the "King of the Clarinet." When he hired Billie Holiday as his band's vocalist, he broke new ground in the cause of racial desegregation.

When Shaw was seven, he moved from a mostly Jewish neighborhood in New York City to New Haven with his father and mother. In New Haven, young Shaw experienced anti-Semitic harassment for the first time. Apparently, it contributed to his introversion, although within only a few years he would overcome it to become a full-time performer.

Stories of Shaw growing up in New Haven weren't usually pleasant. Once, he tried to climb East Rock and got hopelessly stuck, and another time he fell into a well on York Street. In both cases, he was rescued by the New Haven Fire Department. One of Shaw's favorite activities was to attend vaudeville shows at Poli's Theatre in New Haven.

During his New Haven years, young Shaw taught himself to play the ukulele (at age ten), the piano and the saxophone (at age twelve). At age fifteen, he quit school to play the saxophone with a New Haven–area band. The following year, he left New Haven to tour full-time as a musician and soon afterward changed his name to Artie Shaw. But it was when he gave up the saxophone for the clarinet that his career began to take off. By the 1940s,

he was the most famous clarinet player in the country as well as the leader of one of the most popular big bands. A man known for his sayings, Shaw once remarked: "I like the music. I love it and live it, in fact. But for me, the business part of music just plain stinks."

Shaw was married eight times, including to movie stars Lana Turner (1940), Ava Gardner (1945–46) and Evelyn Keyes (1957–85). "People ask what those women saw in me. Let's face it, I wasn't a bad-looking stud. But that's not it. It's the music; it's standing up there under the lights. A lot of women just flip; looks have nothing to do with it. You call Mick Jagger good-looking?" Throughout his music career, Shaw had a desire to write, eventually retiring to produce works of both fiction and nonfiction. He died in 2004 at age ninety-four.

HORROR FILM ACTORS

New Haven has interesting connections with horror film actors. In February 1948, Boris Karloff deviated from almost two decades of monster and mad scientist roles to star in the American premiere of J.B. Priestley's *The Linden Tree* at New Haven's Shubert Theater. An article in the *Hartford Courant* at the time noted: "Theatergoers will have their first opportunity to see Boris Karloff in a sympathetic role."

Fellow horror film star Vincent Price had an even stronger connection with New Haven, when in 1933, he graduated with a bachelor's degree in art history from Yale University. As an undergraduate, he worked on the *Yale Record*, a campus humor magazine. In 1972, Price, who throughout his life was known as an art expert and collector, published *The Vincent Price Treasury of American Art*. In an interview shortly before his death, Price credited the New Haven theaters with helping to direct him toward a life in the theater: "The indoctrination of art at Yale…really set my life's pattern."

In 1992, Vincent Price's correspondence (1920s–80s), memorabilia (1936–80s), scripts (1935–90), writings (1932–81), scrapbooks (1910–70s), and photographs (1890s–1980s) were donated to Yale University Library's Manuscripts and Archives department. The eleven linear feet of the Vincent Price Papers center on his acting career and his work connected with the visual arts.

GEORGE MURPHY

New Haven native George Murphy is little remembered today in his hometown. After a career as a singer, dancer and actor in forty-five movies in the 1930s, 1940s and 1950s, he served as one of California's two U.S. senators from 1965 through 1971.

Murphy was born at his parents' Garden Street home in New Haven on Independence Day 1902. Later, the family, consisting of George's brother Thorne and sister Mabel, moved to Ellsworth Avenue. Their father, Michael, was a Yale track coach and later a U.S. Olympic team coach.

The family moved out of state, but Thorne and George returned to New Haven to attend Yale University. When the academic dean forced George to leave the football team in his junior year, he left Yale, but his brother graduated. During the Second World War, Murphy was placed in charge of organizing entertainment for the armed forces.

George Murphy's career path led the way for another California Republican—Ronald Reagan. They both starred in 1943's *This Is the Army*, Murphy preceded Reagan as president of the Screen Actors Guild (Murphy, 1944–46; Reagan, 1947–52 and 1959–60) and Murphy was elected senator two years before Reagan was elected governor of California. But while Reagan's career would lead to two terms as president of the United States, a cancer operation would leave Murphy unable to speak above a whisper for the rest of his life. In 1970, Murphy released his autobiography, *Say…Didn't You Used to be George Murphy?*.

On a visit to his old New Haven home in 1979, Murphy reminisced about the good old days in the city with a *New Haven Register* reporter: "In the winter we boys used to run across the ice on the pond up on Marvelwood and skinny dip in the summer.…[T]he Yale Golf Course is there today." George Murphy passed away in 1992 at age eighty-nine.

ERNEST BORGNINE

Ernest Borgnine was born in Hamden, Connecticut, in 1917 and later settled with his Italian immigrant parents in a house on Bassett Street in the Newhallville section of New Haven. During the Great Depression of the 1930s, Ernest's father worked for the Works Progress Administration (WPA) on road and bridge construction in New Haven.

Ernest's career in entertainment began in 1935 at the New Haven Arena when he played a clown at a Boy Scout circus. That same year, he graduated from Hillhouse High School and enlisted in the U.S. Navy. After a stint of six years, he returned to New Haven to briefly work with his father, Charles Borgnine, at the Safety Car Heating & Lighting Co. in Hamden.

When World War II broke out, he reenlisted in the navy and served throughout the war. A civilian at war's end, he didn't know what he wanted to do. His mother told him: "Son, you're always acting crazy around the house, you like to make a fool of yourself, why don't you become an actor?" So he moved to New York City and struggled to get stage work. After some success, he moved to California and the movie industry, where he starred in a succession of memorable roles in *From Here to Eternity* (1953), *Demetrius and the Gladiators* (1954) and *Bad Day at Black Rock* (1955).

In 1955, he won an Oscar for Best Actor for his role in the movie *Marty*. When Ernest won the award, his father, still living at his Bassett Street home, took call after call from friends and neighbors. Ernest's sister Evelyn told a *New Haven Register* reporter that when her brother was revealed to be the winner, "the ten or so people in our living room just let out a yelp. We're just very proud and happy for Ernie."

Ernest appeared in significant roles in many major Hollywood productions and, in 1962, starred in TV's popular *McHale's Navy*. In the mid-1980s, he starred in the television series *Airwolf*, and when he was in his eighties and nineties, he did voices for the animated series *SpongeBob SquarePants*. In 1997, the author witnessed the incredible reception that Borgnine received when he was awarded an honorary Doctor of Humane Letters degree by Albertus Magnus College. Ernest Borgnine passed away in 2012 at age ninety-five.

to ʌⱽⱽ.

year before dropping ⱺ.

a renegade semipro baseball teau.

games against some of the top major leaguᴇ ⱺ

was awarded the New Haven franchise in the Eastern Leaᵤ.

In 1932, legendary Yankees owner Jacob Ruppert hired ᵂⱽ·

the Yankees' farm system. He started with four farᵐ·

12

SPORTS STORIES

Although Yale University sports teams have often overshadowed other city sports, New Haven high school teams, local hockey teams and other sports entities were widely celebrated for their notable achievements.

HANDSOME DAN

Yale was the first university in the United States to adopt an animal mascot. The role of Handsome Dan has been filled by eighteen different bulldogs between 1889 and 2018. The first Handsome Dan, who was born on November 6, 1887, belonged to British student Andrew Graves and subsequently to his brother, who also was a Yale student. After the canine's death in 1897, Andrew had him stuffed and sent to Yale for display in a gymnasium. Today, he is preserved in Yale's Payne Whitney Gymnasium.

It wasn't until 1933 that another Dan would appear at Yale. This second Dan was also stuffed upon death and is on display at Yale University Visitor Center. Since Dan II, not a year has passed that Yale didn't have a living Dan successor. In the late 1930s, Handsome Dan III's caretaker was President Jimmy Carter's secretary of state Cyrus Vance, who received two degrees from Yale—his bachelor's degree in 1939 and his law degree in 1942.

YALE BOWL

Yale Bowl, one of the most famous college football stadiums in America, was constructed in 1913–14 at a cost of $750,000. Located on the New Haven–West Haven town line, it covers over twelve acres, and it originally held over 70,000 seats. Renovations in 1994 and 2006 reduced the seating capacity to today's 61,446 seats. Construction of the bowl involved creating entrance tunnels in the open. Then 175,000 cubic feet of dirt from the bottom of the bowl was used to form the surrounding embankment, which covered the tunnel structures.

At the time of its construction, the structure's name was debated. The term *bowl* seemed to lack dignity, but when the alternatives—*stadium*, *amphitheater* and *coliseum*—were ruled out for one reason or another, the name stuck. One New Haven historian stated four years after its opening that the term "The Bowl" had taken on a dignity to "become one of the most honorable of names." The design of the Rose Bowl in Pasadena, California, which opened in 1922, was influenced by the Yale Bowl. The Rose Bowl, in turn, led to the terms "bowl games" and "Super Bowl."

The first Yale Bowl football game in history, on November 21, 1914, was played against Yale's nemesis, Harvard University. Harvard won it 30–6.

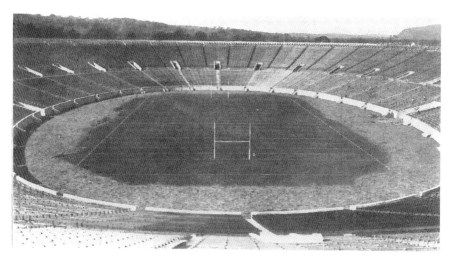

Yale Bowl prior to 1919. *From Everett G. Hill's* A Modern History of New Haven and Eastern New Haven County.

ALBIE BOOTH

One of Yale's greatest athletes was football, baseball and basketball star Albie Booth. Born in New Haven in 1908, Booth graduated from Hillhouse High School. Only five and a half feet tall and weighing less than 150 pounds, halfback Booth played for Yale in the late 1920s and early 1930s.

Booth's College Football Hall of Fame biography states that one 1929 game against Army was "perhaps the greatest single game performance in Yale history." Entering the game with Yale losing 13–0, sophomore Albie Booth scored all of Yale's points (21) and gained 223 yards on 33 carries. A *New York Times* article after the game stated: "It is not by physical force that he achieves his ends, but by the cleverness with which he uses his legs in sidestepping, dodging and slipping past tacklers." After his style was compared with a stop-and-go runner, Booth stated, "I never stop except when I am hit."

After graduating from Yale, Booth played semiprofessional baseball and coached football and basketball. He also was on the management team of the Sealtest ice cream company in New Haven. Booth passed away at age fifty-one in 1959 and was buried in St. Lawrence Cemetery, which is across the street from Yale Bowl. Seven years later, he was inducted into the College Football Hall of Fame.

GEORGE WEISS

For the first thirty-six years of George Weiss's life, he was intimately connected to New Haven. Born in the city in 1894, he attended Yale University for a year before dropping out to work in his family business. In 1915, he founded a renegade semipro baseball team that was good enough to play exhibition games against some of the top major league ball clubs. Four years later, he was awarded the New Haven franchise in the Eastern League.

In 1932, legendary Yankees owner Jacob Ruppert hired Weiss to grow the Yankees' farm system. He started with four farm teams and by 1947 had twenty. Yogi Berra, Phil Rizzuto, Mickey Mantle and Whitey Ford were among the players who were brought up from Weiss's farm system. In 1947, Weiss was named the Yankees general manager, and the following year, he hired Casey Stengel. Between 1949 and 1960, they went on to win ten American League pennants and seven World Series (1949 through

1953, 1956 and 1958), arguably the greatest winning stretch in major league history.

After Weiss and Stengel were pushed to retire after the Yankees' loss in the 1960 World Series, both joined the newly created New York Mets as president and manager, respectively. Weiss remained until his retirement at the beginning of the 1966 season. Three years later, the Mets—who in the previous years were known for their record losses as well as their dedicated New York fans—won the 1969 World Series.

George Weiss was elected to the Baseball Hall of Fame in 1971 and passed away the following year at age seventy-eight.

CHANNEL SWIMMER BETTY COHN

Former New Haven resident Betty Cohn returned to the city in 1949 to swim three miles across New Haven Harbor—from Savin Rock to Lighthouse Point. The *New Haven Register* reported that at the end of her nearly two-hour swim, the fifty-year-old grandmother didn't seem tired but "seemed more like a woman who had just finished a luke-warm shower." She had been followed by a lifeguard and her husband, Dr. Harry Cohn, in a rowboat. Later, the lifeguard remarked, "I've never seen anything like this."

Betty Cohn commented that she had planned to swim a return trip, but the large number of jellyfish were too "annoying." Cohn declared that her next goal was to challenge seventeen-year-old champion swimmer Shirley Mae France to a twelve-mile-long swim across New York Harbor. France was known for having swum thirty-three miles across Michigan's Lake St. Clair when she was fourteen years old. However, according to the *New York Times*, France turned Cohn down, stating, "My goal is to swim the English Channel. Until I do I shall not participate in any competition." Unfortunately, her attempt at the channel failed soon after, and her second attempt the following year was also unsuccessful.

In 1951, the five-foot-five, 164-pound Cohn became the first grandmother to swim the English Channel. She stated, "My advice to all grandmothers is, throw away your rocking chairs and knitting needles and get into the water....I've been swimming 45 years, and I'd rather be in the water than on the land."

NEW HAVEN ARENAS AND THE COLISEUM

Since the beginning of the twentieth century, New Haven has had three major sports and entertainment venues: the 1914 arena on State Street, the 1927 arena on Grove Street and the 1971 New Haven Veterans Memorial Coliseum, which was next to the Knights of Columbus headquarters building.

The first arena opened in 1914, with the Yale hockey team's win over Harvard in February and the International Figure Skating Championship in March. Yale continued to use its ice rink until 1917. The arena burned down in 1924 with no casualties but a loss of 125 automobiles, which were on exhibit.

The second arena was completed in 1927 by developer Abraham Podoloff and his sons. With room for over four thousand spectators, it hosted ice hockey, circuses and concerts. A mainstay from its opening until 1959 were Yale's hockey teams. It was also home to the American Hockey League's New Haven Eagles (1936–52) and the New Haven Blades of the Eastern Hockey League (1954–72). Top performers like Bob Dylan, Joan Baez, the Rolling Stones, the Supremes and the Temptations drew thousands of fans to the arena.

In 1967, Jim Morrison, lead singer of the Doors rock band, made headlines for himself and New Haven after he was arrested onstage at the arena. After being maced for public indecency in a dressing room restroom, Morrison taunted the police from the stage. Officers stopped the show and arrested the singer for inciting a riot. The incident is believed to be the first case of a rock star being arrested during a performance.

The Morrison episode didn't much affect the arena's business, but another development did. The arena couldn't compete with the new New Haven Coliseum, which opened in 1972—the old arena was demolished in 1974.

The third great venue was New Haven Veterans Memorial Coliseum, known as the New Haven Coliseum, which was constructed between in 1968 and 1972. As it would hold about three times as many people as the 1927 arena, urban renewal planners expected it to be a magnet for travelers passing through New Haven on the Connecticut Turnpike.

The New Haven Coliseum concerts began on the evening of October 21, 1972, with *The Bob Hope Show*. Advertised as the "First Concert-Type Performance at the Fabulous New Complex," it starred "The Comedy Star of Stage, Screen, Television, Radio—That Man Himself Bob Hope" as well as popular singer Vic Damone and a twenty-five-piece orchestra. Reserved

Left: *The Bob Hope Show* was the first "concert-type performance" presented at the New Haven Coliseum. *Photo given to author Robert Hubbard by Mr. Hope.*

Below: A late 1990s game between the Beast of New Haven and the Calgary Flames. The Beast played at New Haven Coliseum from 1997 through 1999. *Courtesy New England Photo.*

seats were five, six or seven dollars apiece and included tax. Two months later, in December 1972, Hope would give his ninth and last Christmas show for U.S. troops stationed in Vietnam.

The Coliseum became home to the United Hockey League's New Haven Knights, the New Haven Nighthawks and the New Haven Senators. Concerts by Elvis Presley (his first Connecticut concert was at the Coliseum in 1975), Bruce Springsteen, Frank Sinatra, Van Halen, the Beach Boys and The Who,

as well as the Ice Capades and Ringling Bros. and Barnum & Bailey Circus made it one of the most popular venues in the eastern United States.

The Coliseum's future looked bright until two casinos with world-class entertainment facilities opened in Eastern Connecticut in 1986 and 1996 and took away many of the Coliseum's top performers—and its audiences. In its last days, the Coliseum squeaked by with professional wrestling and monster truck shows. It closed in 2002 and was demolished five years later.

On Saturday morning, January 20, 2007, highway traffic was stopped on the Connecticut Turnpike and Interstate 91 for thirty minutes as the last remaining part of the Coliseum—its four-deck parking garage—was destroyed by implosion using over two thousand pounds of explosives. Composed of forty-eight thousand tons of concrete and steel, the structure fell into a pile of rubble in seventeen seconds. Although fifteen thousand tires had been placed under the structure to absorb its impact, a massive cloud blotted out the sun along the New Haven waterfront. About twenty thousand people watched the demolition from nearby streets and rooftops.

City leaders decided not to attempt a replacement coliseum but to confine their development efforts to attracting small retail establishments and the arts.

MAURICE PODOLOFF

Born in Russia to Jewish parents in 1890, Maurice Podoloff moved to the United States at age six. He graduated from Hillhouse High School in 1909, Yale University in 1913 and Yale Law School in 1915. With his father, Abraham, and two brothers, Podoloff built the New Haven Arena in 1926 and started the New Haven Eagles hockey team, which was a founding member of the American Hockey League.

In 1946, Podoloff was already president of the American Hockey League when he took on the responsibility to simultaneously become the president of the Basketball Association of America. He led the efforts to merge it with the National Basketball League, creating the National Basketball Association (NBA).

He served as the NBA's first commissioner from 1949 to his retirement in 1963. Ironically, although he played a key role in managing and growing the sport with the tallest players—professional basketball—Maurice Podoloff was only five feet, two inches tall.

Podoloff was inducted into the Basketball Hall of Fame in 1974, and the trophy for the National Basketball Association's Most Valuable Player Award is named for him. The Hall of Fame's biography of Podoloff states that his "great organizational and administrative skills were later regarded as key to keeping the league alive in its often stormy, formative years." In 1985, at age ninety-five, Podoloff passed away in Yale–New Haven Hospital.

FLOYD LITTLE

At age thirteen, Floyd Little moved with his parents and his three sisters and two brothers from Waterbury, Connecticut, to a small apartment in New Haven. A horrible student and troublemaker, Little was kicked out of school. But determined to turn his life around, he ran for class president and won. Moving on to Hillhouse High School, he became a local football legend.

Along with his success in sports, Little raised his SAT scores dramatically and was accepted at Syracuse University, where he became a three-time All-America running back. In the 1967 AFL-NFL Draft, he was the Denver Broncos' first-round draft pick. Throughout his pro career (including in his rookie year), Little was the Denver Broncos' team captain.

In 1971, Little became the first 1,000-yard rusher in Broncos' history. When he retired in 1975 after nine seasons, Little was the NFL's seventh all-time leading rusher, with 6,323 yards rushing. He also had a career total of more than 12,000 all-purpose yards and scored 54 touchdowns.

Floyd Little was elected to the College Football Hall of Fame in 1983 and the Pro Football Hall of Fame in 2010. In 2011, when the New Haven Athletic Center was renamed the Floyd Little Athletic Center, Little said at the dedication: "No one could ever believe that a guy who came from this area, with very little means, could rise up to be an all-city, all-state, All-American, All-Pro, College Football Hall of Fame and Pro Football Hall of Fame player. It's an unbelievable story, but I feel that I've been truly blessed."

SCIENCE AND MEDICINE

N ew Haven has always been at the forefront of public health. In 1872, it became the first city in Connecticut to establish a department of health as a branch of the municipal government, and it was the first Connecticut city to pass plumbing ordinances. Here we cover some of the diseases that hit the area hard and the brave and talented men and women who have protected its citizens.

YALE–NEW HAVEN HOSPITAL

Yale–New Haven Hospital was founded in 1826 as an institution to care for the poor. Its first facility was called the State Hospital, and it opened in 1833 with thirteen beds. It was located on seven and a half acres between Cedar Street, Howard Avenue, Davenport Avenue and Congress Avenue.

During the Civil War, the U.S. government used the facility to treat sick and wounded soldiers and renamed it Knight U.S. Army General Hospital. Yale surgeon Pliny Adams Jewett (1816–1884) was put in charge of the one-thousand-bed military hospital. The name was changed again in 1884 to New Haven Hospital, and in 1913, it was formally affiliated with Yale University's medical school.

Yale New Haven Hospital's contributions to medical science are enormous. Although penicillin was discovered by Scottish scientist Alexander Fleming

in 1928, it wasn't until March 14, 1942, at Yale in New Haven that it was first used to treat blood poisoning (streptococcal sepsis).

In 1945, the name was again changed—to Grace–New Haven Hospital—after it merged with New Haven's Grace Hospital. In 1965, an increased connection with Yale University resulted in the most recent name change—Yale New Haven Hospital. In 2012, Yale New Haven Hospital merged with New Haven's Hospital of Saint Raphael, which served the people of New Haven since its founding by the Sisters of Charity of St. Elizabeth in 1907. The latter's facility, located on Chapel Street, is today designated as the hospital's Saint Raphael Campus.

SMALLPOX

Before the eradication of smallpox in the latter half of the twentieth century, the disease wreaked havoc everywhere, including New Haven. In February 1890, the New Haven Board of Selectmen voted unanimously to construct a new pest house (a building for housing people suffering from infectious diseases) at Springside farm. The old facility was deemed to be in too remote a location. The motion was prompted by a recent smallpox scare.

In November 1892, a girl, Malvina Gibson, died from smallpox at New Haven Hospital. Another patient, Michael Callahan, was in critical condition. Other smallpox sufferers at the hospital included Pedro Garvonni, an Italian immigrant; William Ricks, an African American; and Charles Nicholson, an employee in the surgical ward. A few people were so frightened that they attempted to break out of the quarantine. The hospital's guard force was doubled to sixteen men to prevent another such incident.

In April 1902, the New Haven Jail was under quarantine after Charles Greenwood, a Waterbury man jailed for drunkenness, was found to have smallpox. As one newspaper article stated: "Keepers, guards and all are now prisoners." This included Sheriff Dunham's family, who lived at the jail, but not the sheriff, who happened to be away when quarantine was imposed. Dunham stayed in a hotel until the quarantine was lifted two weeks later.

YELLOW FEVER IN 1794

Smallpox wasn't by any means the only contagious disease problem in early New Haven. In 1794, yellow fever threatened the 3,500 inhabitants of the city. In June of that year, a small sailing ship arrived in New Haven Harbor. Earlier, it had been used to move yellow fever patients between islands in the Caribbean Sea. Within days, one New Haven resident was diagnosed with yellow fever, followed by another, and then another. It was decided to cancel the 1794 session of the Connecticut General Assembly that was scheduled to be held in New Haven. It was held in Middletown instead.

From Middletown, Connecticut governor Samuel Huntington and his council issued a statement in October to be publically read in the churches of Connecticut. It asked that the people of the state "contribute for the relief of their fellow-citizens of New Haven and that the sums collected by contribution as aforesaid, be paid over as speedily as convenient will permit to the civil authority and selectmen of New Haven to be applied by them to the relief of these who have been afflicted with and suffered by, the said yellow fever."

By November 1794, 150 residents of New Haven had contracted yellow fever, and sixty-four had died of it. New York City and Philadelphia were hit with yellow fever outbreaks in the same year. Today, we know the yellow fever virus only infects primates (including humans) and some species of mosquitoes.

EMELINE ROBERTS JONES:
AMERICA'S FIRST WOMAN DENTIST

In 1854, at age seventeen, Emeline Roberts married twenty-year-old Dr. Daniel Jones, a dentist in Danielson, Connecticut. Soon, she became interested in dentistry. Although her husband at first tried to discourage her, Emeline secretly practiced by filling hundreds of teeth that her husband had extracted. Her work so impressed Daniel that in 1855 he allowed her to assist him. In 1859, when she was twenty-three, he made her his official partner. She became the first woman to practice dentistry in the United States.

In 1864, Daniel Jones passed away, leaving Emeline with a six-year-old daughter, Eveline, and a three-year-old son, Daniel. It was then that she decided to open up her own independent dental practice—the first woman

in the United States ever to do this. She began a traveling dental practice, using a portable dentist chair, to see patients in eastern Connecticut and Rhode Island. In 1876, at age forty, she set up a permanent dental practice in New Haven and treated patients there for thirty-nine years. Well known in the dental profession both within Connecticut and throughout the nation, Emeline Roberts Jones was elected to the Connecticut State Dental Society in 1883. At the end of the century, she became one of the first dentists to be licensed in Connecticut. She passed away a year after her 1915 retirement.

Emeline earned enough in her dental practice to send her son, Daniel (1860–1936), to New Haven's Hopkins Grammar School, which was one of the top preparatory schools in the country. In 1889, he graduated from Harvard Dental School and, in 1890, received his MD degree from Yale Medical School. He practiced dentistry in New Haven for decades. Emeline's granddaughter and namesake, Emeline Street (born 1884), graduated from Vassar College in 1905.

DR. MILDRED B. WINSLOW

After graduating from the Philadelphia Optical College in 1909 and the Northern Illinois College of Ophthalmology and Otology in 1912, Dr. Mildred B. Winslow practiced optometry for a few years in Kansas. She opened her practice in New Haven in 1921, and for many years, her office was in the commercial building at 839 Chapel Street. As an officer of the Connecticut Optometric Society, Winslow was instrumental in organizing its women's auxiliary.

In 1958, the New Haven District Optometric Society honored Dr. Mildred B. Winslow on the occasion of her forty-eight years as an optometrist. In 1959 at age seventy-two, Dr. Winslow moved her home and office to Main Street, Hartford. She passed away in 1982 at age ninety-five.

From the American Optometric Association (AOA) founding in 1898 until 1973, Dr. Mildred Winslow was one of only seven women optometrists in AOA leadership. As of 2018, forty-four thousand doctors of optometry are members of the AOA, and three of the ten members of its board of trustees (including the president-elect) are women.

JOSIAH WHITNEY

Born in 1819, Yale-educated geologist Josiah Whitney became one of America's most influential scientists. In 1864, while he was director of the California Geological Survey, his fellow members honored him by naming the tallest mountain in California after him—Mount Whitney. The 14,500-foot-high mountain's summit is also the highest in the contiguous United States.

Whitney attended Yale for three years, studying chemistry, mineralogy and astronomy, as well as learning to ride, dance, fence and play three musical instruments. In 1837, he wrote to his sister Elizabeth that he walked the "streets and alleys of New Haven" to get exercise. Writing to her after his 1839 Yale graduation ceremony, Whitney stated, "[A] better commencement had not been attended in New Haven, and that a finer class never left the walls of Old Yale." He commented that none of his family had been present and graduates feasted on roast pig and succotash at their commencement dinner for a fee of two dollars.

Whitney returned to New Haven in 1870 to receive an honorary LLD degree from Yale. After decades as a professor of geology at Harvard University, Whitney passed away in 1896.

DR. MARION EDITH HOWARD

The daughter of an English sea captain who had served in both the British navy and the U.S. Merchant Marine, Marion Edith Howard received her medical doctor degree from John Hopkins University in 1931. She moved to New Haven in 1932 and worked at New Haven Hospital, where she was an excellent diagnostician of heart and circulation issues and specialized in communicative disease management. From 1936 to 1956, she was first an instructor and then a professor at Yale Medical School. Three events in 1942 changed Dr. Howard's life forever: she married professor of surgery A.W. Oughterson, started up a private practice and made history as the first person in the United States to use penicillin to treat blood poisoning (streptococcal sepsis).

Although penicillin was discovered by Alexander Fleming in 1928, it wasn't until March 14, 1942, that Dr. Marion Edith Howard administered it to a patient dying of streptococcus infection—the patient dramatically improved, making a full recovery.

In 1956, Dr. Howard and her husband requested a leave of absence from Yale Medical School and moved to Colombia on a Rockefeller Foundation medical mission. Two months later, he was killed in a plane crash along with thirty-six other people. He had been visiting all medical centers in Colombia as part of his role as a medical education consultant. Dr. Howard returned to New Haven to settle her husband's estate, then returned to Colombia to continue the mission work. In 1959, she died in Colombia from natural causes at age fifty-four. She was buried in Cali, Colombia.

Professor Chester Longwell and the Shimmying House

One of the most productive American field geologists of the 1800s was Chester Ray Longwell. His extensive field experience in Nevada and Arizona, the Black Hills of South Dakota and many other locations benefited the U.S. Geological Survey. In addition, he remained on the Yale University faculty for thirty-six years and was appointed professor emeritus upon his retirement in 1956.

In the 1920s, New Haven had a mystery house on Bishop Street. Occupants of the building complained that in the middle of the night the house would sway back and forth, causing beds, couches and chandeliers to swing for no apparent reason. Soon the structure became known as the "shimmying house." Investigations showed the building to be structurally sound, and there was an absence of nearby disturbances that might cause the nighttime swaying. Finally, Yale geology professor Chester Longwell came up with the answer. In 1928, he determined that the movement of the house was caused by railroad trains six blocks away. Both the house and the train tracks were located on top of a stratum of rocks. The reason the building moved only at night was that only at that hour would the heaviest trains pass over those tracks.

In the late 1930s and early 1940s, Professor Longwell (1887–1975) headed up a committee of sixteen geologists to create the first tectonic map of the United States, covering all territory between the Atlantic and Pacific Oceans.

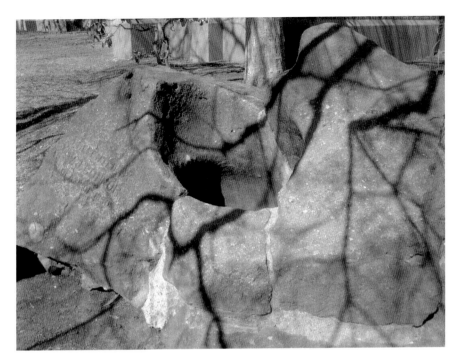

A sandstone pothole on display in front of the Peabody Museum on Whitney Avenue. *Authors' collection.*

DR. WILLIAM W.L. GLENN

Cardiac surgeon William W.L. Glenn, who was chief of cardiovascular surgery at Yale University from 1948 through 1975, invented an early artificial heart pump with his student William H. Sewell (?–1993). The latter was working on his thesis at Yale University School of Medicine.

The 1948–50 model was created using glass and rubber tubing, simple valves and a motor from one of A.C. Gilbert Company's Erector Sets. The device was then connected to a tank of compressed air, and a vacuum pump was used to successfully bypass the right side of a dog's heart for more than an hour. (The dog survived.) The original Erector pump is now at the Smithsonian Institution's National Museum of American History in Washington, D.C. Both Sewell and Glenn published their findings in the article "Experimental Cardiac Surgery: I. Observation on the Action of a Pump Designed to Shunt the Venous Blood Past the Right Heart Directly

into the Pulmonary Artery," which appeared in the September 1950 issue of the journal *Surgery*.

Dr. Glenn ran a U.S. Army field hospital in France during World War II. In 1954, he developed the "Glenn Shunt," which bypassed "malformed right chambers of the heart." It allowed physicians to treat "blue babies," whose hearts didn't provide sufficient blood to their lungs, which gave their skin a bluish color. Later, Glenn became the first surgeon to be named president of the American Heart Association.

A Renaissance man, Glenn's interests ranged from the life of Benjamin Franklin to collecting early American silver and from Yale football (he lived near Yale Bowl) to fly-fishing. Dr. Glenn died in 2003 at age eighty-eight.

After graduation from Yale Medical School, co-inventor Sewell served in the U.S. Navy during the Korean War and was head of the Naval Medical Research Institute's experimental surgery section. In a career that included positions in New York, North Carolina and Pennsylvania, Sewell performed 2,556 heart operations. Like Glenn, Sewell was a man of many interests, such as flying his own airplane and gardening.

14

NOTEWORTHY PEOPLE

I n the preceding chapters, we have mentioned many of New Haven's most illustrious and, in some cases, most notorious citizens. There are many more people who are part of the "hidden history" of New Haven, and here are a few of them.

OTHNIEL CHARLES MARSH

Born on October 29, 1831, Othniel Charles Marsh became arguably the greatest paleontologist of the nineteenth century. He graduated from Yale in New Haven in 1860 and continued graduate work at Yale and at German universities. In 1866, O.C. Marsh's uncle and philanthropist George Peabody (1795–1869) donated $150,000 to found the Peabody Museum of Natural History at Yale, and Marsh was appointed Yale Professor of Paleontology, a position he held until his death thirty-three years later.

Marsh made several major expeditions to the American West with his students. On one in 1874, his party was twice repulsed by Sioux warriors who thought the scientists were seeking gold near the Black Hills. Marsh met several times with Chief Red Cloud and other Sioux leaders, who granted him permission to search for bones on their lands. Marsh, in turn, promised the Sioux to take samples of the tribe's food rations to the president of the United States. Marsh brought the Indian complaints to Washington, D.C.,

Yale professor Othniel Charles Marsh named this dinosaur *Torosaurus* in 1891. This statue stands outside of the university's Peabody Museum. *Authors' collection.*

and exposed fraud committed against the Indian tribes. Red Cloud later presented Marsh with a pipe and tobacco pouch and wrote that Marsh was the only white man he had seen who kept his promises. Red Cloud gave him the title the "bone-hunting chief."

During his long career, Marsh named about five hundred new species of fossil animals that had been discovered by him or his associates. Some of the thirty-two dinosaur genera Marsh is credited with naming are: the stegosaurus in 1877, the diplodocus in 1878, the brontosaurus in 1879 and the triceratops in 1889.

In 1883, Chief Red Cloud traveled to Washington, D.C., to request that his tribe be reimbursed $10,000 for horses that were taken by General Crook. He took the occasion to visit Professor Marsh at his home. While in New Haven, he received over one hundred callers, including the mayor, other Yale professors and "prominent citizens." Red Cloud's itinerary included visits to New Haven's fire department and the Winchester corporation armory.

One friend described Marsh about that time as "of middle height, with a robust well-knit frame and massive head. Ruddy and of a fair countenance,

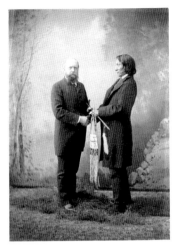

Left: Professor Othniel Charles Marsh greeting Oglala Lakota leader Red Cloud in New Haven in 1883. *Courtesy National Portrait Gallery, Smithsonian Institution.*

Below: Othniel Charles Marsh's mansion on Prospect Street was completed in 1878 and left to Yale University upon Marsh's death in 1899. *Authors' collection.*

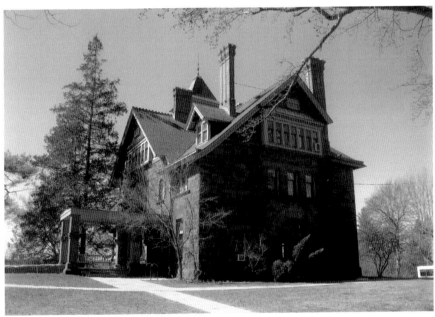

he has blue eyes which often twinkle humorously." Marsh died in 1899 and is buried in the city's Grove Street Cemetery. His grave marker states: "To Yale University he gave his services, his collections, and his estate."

Today, Marsh's 1878 mansion at 360 Prospect Street is known as Marsh Hall and is occupied by Yale's School of Forestry and Environmental Studies. Marsh bequeathed the grounds that surrounded his mansion to Yale, and today they are known as the Marsh Botanical Gardens.

DOC CARVER

One of New Haven's most interesting people was nineteenth-century sharpshooter William Frank "Doc" Carver (1851–1927). Like the other famous "Doc" of the Wild West—Doc Holliday—Carver earned his title from his years of practicing dentistry. On August 20, 1878, Carver married Josephine Dailey in New Haven and had two children, son Al and daughter Lorena.

In 1878, William Wirt Winchester, treasurer of the Winchester Repeating Arms Company, arranged for Carver to put on one of his most famous shows at New Haven's Quinnipiac Range before five thousand spectators. Attendants set up barrels of glass balls and an array of Winchester rifles. Dressed for the occasion, Carver wore a large gold shield on his belt with the words: "Dr. W.F. Carver, Champion Rifle Shot of the World." He started his demonstration by

William Frank "Doc" Carver established an outdoor western show with William F. "Buffalo Bill" Cody in 1883. *From a William Frank Carver studio portrait.*

shooting down balls pitched at him from fifty feet away. Then he shot silver dollars thrown up by volunteers. Within seventy-two and a half minutes, he broke one thousand glass balls that were thrown into the air one or two at a time. He finished the show by shooting pennies and nickels out of the air.

A *Hartford Courant* article from 1883 stated: "When [Buffalo Bill] Cody played here [Hartford, Connecticut] on the 7th of last February, Dr. Carver, whose home is in New Haven, came here to consult with him on the advisability of starting an outdoor show." Later, in 1883, they teamed up to produce the western show Cody and Carver's Wild West. They split after one season, with Cody renaming his show Buffalo Bill's Wild West Show.

Later, Carver invented a new type of act—horse diving shows. In 1894, he began appearing at state fairs and dove a horse head-first from a tall platform into a pool of water. He continued the act for thirty-three years—only stopped by his death in 1927 at age seventy-six. Carver's son Al and Al's wife, Sonora Webster Carver, continued with the act and established it as a top attraction at the Steel Pier in Atlantic City, New Jersey, diving horses from a sixty-foot-high platform. In 1931, twenty-seven-year-old Sonora was

on her horse when it hit the water at the wrong angle, she didn't have time to close her eyes, and both of her retinas were detached. Although blinded for life, she continued the horse diving act for another eleven years. She passed away in 2003 at age ninety-nine. In the 1970s, animal rights protests forced the end of most horse diving acts.

WILLIAM HOWARD TAFT

Born in Ohio in 1857, William Howard Taft, the twenty-seventh president of the United States, was a full-time Yale student and subsequently worked as a Yale professor. His father, Yale graduate Alphonso Taft, had been attorney general and secretary of war in President Ulysses S. Grant's administration. At Yale, both Tafts were members of the Skull and Bones secret society.

After graduating from Yale, William Howard Taft rose from office to office: solicitor general of the United States (1890–92), United States

Tomb-like building of Yale University's Skull and Bones (circa 1900–1915), a secret society open to select seniors. *Courtesy of the Library of Congress.*

U.S. president William Howard Taft was a Yale University graduate and, after his presidency, a Yale professor. *Courtesy of the Library of Congress.*

Court of Appeals judge (1892–1900), governor-general of the Philippines (1901–3), secretary of war (1904–8) and president of the United States (1909–13).

During his presidential years, Taft sometimes weighed over 350 pounds, easily the heaviest president in U.S. history. After he lost the 1912 presidential election to Woodrow Wilson, he was offered Yale University's Kent Chair of Constitutional Law. He responded that it would not be adequate, but that "a Sofa of Law" might be all right. Several oversized chairs were constructed at Yale for the former president. One is still in its original location: William Howard Taft's seat in the balcony of Yale's Woolsey Hall auditorium. Taft stayed at the university until he was appointed chief justice of the United States in 1921. It was a position he would hold until his death in 1930.

FRANCES SHELDON BOLTON:
PARENT-TEACHER ASSOCIATION FOUNDER

New Haven is the birthplace of the Parent-Teacher Association of Connecticut through the efforts of Frances Sheldon Bolton (1863–1936). This was an outcome of Bolton's attendance at the 1897 National Congress of Mothers in Washington, D.C., where two thousand people met and formed the National Parent Teacher Association. After three years, she took the step of holding the first Connecticut PTA meeting, and only ten people attended (a setback since she had advertised this in her *Mothers' Journal* and handwrote 350 letters of invitation). By the time of Bolton's death, the Connecticut PTA had grown to twenty thousand members.

As Connecticut PTA president, Bolton advocated for children as the association does today. In 1901, Connecticut law granted both father and mother joint charge of their minor children with the mother as sole guardian upon the father's death. This was a huge accomplishment, considering that women didn't even have voting rights prior to 1920. In 1903, the Frances Sheldon Bolton Bill was passed unanimously, preventing juveniles from being placed in jails with hardened criminals. Today, the state PTA's nonprofit volunteer headquarters is in New Haven, where it originated.

Prior to the PTA, Frances Sheldon Bolton founded a group of Mothers' Clubs. When women became bored in attending sessions that trained them to become better mothers—she and her daughters "sugar-coated" it by ending the meetings with "the most delightful parties imaginable." Bolton was asked to organize other Mothers' Clubs throughout Connecticut. This author remembers her own mother belonging to a church-affiliated Mothers' Club. One night every month, the club would be hosted at a member's home, and the meeting began with prayer or scripture reading followed by child-rearing strategies, practical advice for parental concerns and dessert amid much laughter and congeniality.

In 1883, when Bolton did on-site nurse-training in a hospital maternity ward in Massachusetts, she learned that babies needed love and security—but not spanking when they cried. Her four S's of a baby's needs were simple: soap, soup, sunshine and smiles. In 1893, she published *Mother Goose in Kindergarten*, where a child drew pictures in the margins to the retold (and less frightening) Mother Goose rhymes.

From 1894 to 1904, she edited and published an informational monthly magazine, *Mother's Journal*, and excerpts were published in her popular book *Baby*. It sold for twenty years and is considered the first book written on

practical advice for child care. At times, Frances Sheldon Bolton stood alone; she said she was called "dangerous," as she organized women, but she moved forward as a social activist, civic leader and a pioneer of parent education and children's welfare.

Sinclair Lewis

Novelist Sinclair Lewis, the first American to win the Nobel Prize in Literature, began his professional writing career in New Haven. Between 1905 and his graduation from Yale College with a bachelor's degree in 1907, he worked for the *New Haven Journal-Courier* on State Street, and during his off-hours, he was an editor for the *Yale Literary Magazine*.

Receiving a starting pay of nine dollars per week at the *Journal-Courier*, Lewis spent six hours per night covering minor stories, such as club meetings and small fires. When he left work at about midnight, Lewis would usually have a late supper of hot dogs and beans at a Judd's café, which was across the street from the newspaper office.

Fifteen years after leaving the *Journal-Courier* job, Lewis told a *Hartford Courant* reporter that after someone is a newspaper reporter, "he is less fitted to write fiction than before because of the hurried work…and the necessity for turning out stories that are standardized." Lewis passed away from complications of alcoholism in 1951 at age sixty-five.

Hiram Bingham III

Often called a real-life Indiana Jones, Hiram Bingham III was born in Hawaii to a missionary family and graduated from Yale University in 1898. While teaching at Yale, he achieved his greatest fame—as the explorer of Peru's Machu Picchu, also known as the "Lost City of the Incas." After his first Yale expedition to Peru in 1911, he returned several more times. In November 1924, he was elected governor of Connecticut. In the following month, he was elected U.S. senator in a special election to finish an unexpired term. In January 1925, he served as governor for one day, resigned and continued to serve as one of Connecticut's two U.S. senators for the next eight years.

This 1921 painting of explorer and U.S. senator Hiram Bingham III is by artist Mary Foote. *Courtesy Library of Congress, Prints and Photographs Division.*

Bingham passed away in 1956 at age eighty. Peru named the road that brings tourists from the Urubamba River to Machu Picchu the Hiram Bingham Highway. It's believed that a quarter of a century after Bingham's death, his life inspired the creation of an iconic fictional hero—Indiana Jones.

In 2016, Bingham's twenty-three-thousand-square-foot mansion on New Haven's Prospect Street (which for years had been a resident dormitory for Albertus Magnus College students) was renovated to serve as a drug treatment home for young women.

GRACE MURRAY HOPPER

Born in 1902, Grace Murray Hopper received degrees in mathematics and physics at Vassar College and earned two graduate degrees in mathematics from Yale University: a master's degree in 1930 and a doctorate in 1934.

During World War II, Hopper joined the U.S. Naval Reserve (Women's Reserve), where she was part of the team working on the MARK I, the first electromechanical computer in the United States. In the 1950s, she worked on the first commercial electronic computer. During the decade, she pioneered the development of word-based computer languages and worked on the development of COBOL, which for decades was the most popular language for business applications.

In 1972, Hopper received Yale's Wilbur Lucius Cross Medal, which is awarded to alumni for "distinguished achievements in scholarship, teaching, academic administration, and public service." When she retired from the

U.S. Navy rear admiral and legendary computer scientist Grace M. Hopper earned two degrees in mathematics from Yale University. *Courtesy of the United States Navy.*

navy at age seventy-nine, she was the oldest serving officer in the armed forces. A reservist for almost forty years, Hopper died in 1992 at age eighty-five. In 1996, the U.S. Navy launched the guided-missile destroyer USS *Hopper*. In 2017, Yale's Calhoun College was renamed Grace Hopper College in her honor.

GEORGE H.W. BUSH

In 1946, when the newly married twenty-one-year-old George H.W. Bush transferred from military life to become a Yale student, he was in good company—about 5,000 out of the 8,500 men at Yale that year had also served in the war. His father and four of his uncles had been Yale graduates. In only two-and-a-half years, Bush received his bachelor's degree in economics with a minor in sociology. He found time to play baseball each year, becoming team captain in his final year. After brief stays in apartments at Chapel and Edwards Streets, George and Barbara Bush settled in at 37 Hillhouse Avenue with the families of about a dozen other Yale students.

During their first year, Barbara kept score at her husband's baseball games while pregnant with future U.S. president George W. Bush. She was protected by the home plate safety net. In 1946, Yale's baseball team played Princeton. Before the game, captain George Bush walked onto the field to

This is the Hillhouse Avenue home of two men who would become presidents of the United States: George H.W. Bush and George W. Bush. *Authors' collection.*

accept for the university a manuscript of Babe Ruth's memoirs from the hands of the great home run king himself. Ruth was destined to die in two years, Bush to be elected U.S. president in forty-two years.

GEORGE W. BUSH

Many U.S. presidents have visited New Haven, but only one was born there—George W. Bush. On July 6, 1946, the future forty-third president of the United States was born to Barbara and George H.W. Bush in New Haven's Grace–New Haven Community Hospital (now Yale–New Haven Hospital). At the time, his father, the future forty-first president, was a sophomore at Yale University. For the first two years of the younger Bush's life, he lived with his parents at 37 Hillhouse Avenue.

At age two, George W. Bush's first period of residence in New Haven ended, and he and father George and mother Barbara moved to Texas.

In the 1960s, George W. Bush returned to New Haven to attend Yale University. As the son and grandson of Yale graduates who were highly successful, George had little difficulty in being accepted at Yale. According to Jean Edward Smith in his biography *Bush*, young George at Yale was "a rough-edged Texan among preppies" and "placed himself at the center of those who sought to make the college years enjoyable." Bush received his BA degree in 1968 and quickly put his Yale years behind him. It would be over three decades before he would return to the Yale campus—when he attended his daughter Barbara's 2001 graduation.

BILL CLINTON AND HILLARY RODHAM CLINTON

As soon as Bill Clinton entered Yale Law School, he became a coordinator for the U.S. Senate campaign of Connecticut anti–Vietnam War candidate Joseph Duffy. He also clerked for local attorneys, working on torts, estates and contracts. In 1972 and 1973, he was employed as an instructor at the University of New Haven, teaching courses in constitutional law and criminal justice. During 1972, he held key positions in George McGovern's unsuccessful presidential campaign.

During her time at Yale, Hillary Rodham Clinton was a law clerk for the New Haven Legal Assistance Association and a research assistant for Yale Law School professor Joseph Goldstein. In the summer of 1972, she worked for the Democratic National Committee as a coordinator on voter registration effort in Texas.

According to Hillary Clinton, she and Bill first spoke to each other in Yale's law library after she noticed him staring at her. In her autobiography, she explains that she walked over to him and said, "If you're going to keep looking at me, and I'm going to keep looking back, we might as well be introduced. I'm Hillary Rodham."

Both Clintons graduated from Yale Law School in 1973. They were married in 1975. After twelve years as the governor of Arkansas, Bill Clinton was elected the forty-second president of the United States in 1992 and reelected in 1996. Hillary Clinton served as a U.S. senator from 2001 until 2009, was appointed U.S. secretary of state in 2009 and, in 2016, became the first woman nominated by a major political party to run for president of the United States.

JOSEPHINE THOMAS

In 1924, Josephine Thomas opened the first children's bookstore in New Haven. This was a new venture in Connecticut, as stores solely focused on children's literature could only be found in New York, Boston and Europe. After earning her degree at the Carnegie Library School of Pittsburgh, she returned home to serve New Haven's youth by heading up the children's department at New Haven Public Library for more than eight years. Thomas wanted to provide children a place where their curiosity and reading could blend, and her chief interest was to provide books that satisfied their interests.

When children visited Thomas's bookstore, they would spend hours reading her decorative state map, which included tiny drawings of important Connecticut buildings or historical scenes—her cartography skills taught children not only valuable information but also their correct location. It was her belief that child psychology courses are important in her profession as well as love of children, patience and the ability to look at the world "through the eyes of a child."

MAYA LIN

American architect and sculptor Maya Lin, born in 1959, is the daughter of Chinese refugees. She is best known as the designer of the Vietnam Veterans Memorial in Washington, D.C. As a twenty-year-old Yale University undergraduate student, Maya Lin submitted a design amid 1,400 anonymous entries for the national memorial. She was a senior at Yale when it was accepted. Her design was created as part of an architecture course—it beat out her professor's entry—but she received only a B in the course. Lin graduated in 1981 and returned to Yale to complete her architecture master's degree in 1986.

The Vietnam Veterans Memorial's V-shaped wall of glossy black, reflective granite unites our past as it points toward the Washington Monument and the Lincoln Memorial. Lin's vision was for two V-shaped walls to grow in height and meet in the middle like a "wound that is closed and healing.... They can never come back. They should be remembered." More than fifty-eight thousand half-inch names are starkly etched upon a mirror-like surface, listed chronologically by their sacrifice. There was much controversy over

this memorial, but it is now one of the most popular sites to visit. In 1982, private funding of $8.4 million paid for this memorial, which is almost 250 feet long, honoring the brave men and women who served in the Vietnam War—names in black designate the MIA (missing in action). A 2010 study found this memorial gives Vietnam veterans' ability to cope better with their PTSD (post-traumatic stress disorder), perhaps because it can inspire contemplation, reflection, interaction and acceptance; it is sometimes called the healing wall.

Many of Maya Lin's pieces use the environment and natural elements. Two other pieces that Lin designed are the Civil Rights Memorial in Montgomery, Alabama (1989), and the Eleven Minute Line in Sweden (2004). At Yale, to commemorate the coeducation of women, she designed the Women's Table, which symbolically represents women at Yale in spiraling numbers that end in 1993, the year the sculpture was completed. This bowl-like sculpture, with water lapping at its edge, evokes a sense of calm; it is located on the Rose Walk, which connects Elm and Wall Streets.

ELLEN BREE BURNS

Ellen Bree Burns was born in New Haven in 1923 and graduated from the then all-female Albertus Magnus College in 1944. Three years later, she received a degree from Yale Law School. After serving as an attorney for Connecticut General Assembly's Legislative Legal Services (1949–73) and a judge on the state's Circuit Court and the Court of Common Pleas, she became a Connecticut Superior Court judge in 1976.

In 1978, she was nominated by President Jimmy Carter to the United States District Court for the District of Connecticut. She was the first woman to hold that position. Her service began in 1978, and she became its chief justice in 1988, in which role she remained until 1992. When Judge Burns retired in 2015 at age ninety-one, she was the longest-serving woman judge in the federal court system.

BIBLIOGRAPHY

Books, Motion Pictures and Web Publications

"Addresses Delivered at the Laying of Corner Stone of the Federal Building, In New Haven, Connecticut, June 4, 1914." United States District Court for the District of Connecticut. June 4, 1914. ctd.uscourts.gov/sites/default/files/forms/Cornerstone%20Fed%20Ct%201914.pdf.

"Annual Report of the United States Life-Saving Service." Google Books, Treasury Department, 1886, books.google.com/books?id=SZw6AQAAMAAJ.

Atwater, Edward E. *History of the Colony of New Haven to Its Absorption into Connecticut.* Meriden, CT: Journal Publishing Company, 1902.

Bacon, Leonard Woolsey. *Historical Discourse, on the Two Hundredth Anniversary of the Founding of the Hopkins…Grammar School, New Haven, Connecticut: Delivered.* N.p.: T.J. Stafford, 1860.

Baldwin, Ernest Hickok. *Stories of Old New Haven.* Taunton, MA: C.A. Hack and Son, 1907.

Bennett, Irving. "Women on the AOA Board." Optometry Cares, The AOA Foundation. www.aoafoundation.org/ohs/hindsight/women-on-the-aoa-board.

Biographical Directory of the U.S. Congress. "Hillhouse, James (1754–1832)." bioguide.congress.gov/scripts/biodisplay.pl?index=h000618.

Brewster, Edwin Tenney. *Life and Letters of Josiah Dwight Whitney.* Boston: Houghton Mifflin Company, 1909.

Bridges, T.C. "Ghosts of the Sea." *Strand Magazine* (1908): 66–67.

Center Church on the Green. "The Crypt—Center Church on the Green—New Haven, CT." centerchurchonthegreen.org/history/crypt.

Clinton, Hillary Rodham. *Living History: Hillary Rodham Clinton.* New York: Scribner, 2004.

Connecticut Bureau of Labor Statistics. "Seventeenth Annual Report of the Connecticut Bureau of Labor Statistics." Journal Publishing Company, 1901.

Farnam, Henry W. *Biographical Record of the Class of 1874 in Yale College.* Part Four, *1874–1909.* New Haven, CT: Tuttle, Morehouse & Taylor Co., 1912.

Farnham, Thomas, et al. *New Haven: The Earliest Years, The Bicentennial Radio Series.* Volume 1. New Haven, CT: New Haven Bicentennial Commission, 1976.

———. *New Haven: The Making of the Modern Community, The Bicentennial Radio Series.* Volume 3. New Haven, CT: New Haven Bicentennial Commission, 1976.

———. *New Haven: The Revolutionary Generation, The Bicentennial Radio Series,* Volume 2. New Haven, CT: New Haven Bicentennial Commission, 1976.

"Forest and Stream." *Forest and Stream,* 1895.

Frank Pepe Pizzeria. "About Us." pepespizzeria.com/about.

Frengel, Elizabeth. "'To Set the World at Nought': The Prayer Book of Sir Thomas More." Beinecke Rare Book and Manuscript Library., Archibald MacLeish Collections. March 14, 2016. beinecke.library.yale.edu/about/blogs/research-files/2016/03/14/%E2%80%9C-set-world-nought%E2%80%9D-prayer-book-sir-thomas-more.

Green, Judy, and Jeanne LaDuke. *Pioneering Women in American Mathematics: The Pre-1940 PhDs.* Providence, RI: American Mathematical Society, 2009.

Henkels, S.V., et al. *Catalogue of the Col. John Trumbull Letters and Papers Including Those of Benjamin Silliman…and Many Rare Portraits.* N.p., 1897.

Hill, Everett G. *A Modern History of New Haven and Eastern New Haven County.* New York: S.J. Clarke, 1918.

Howe, Henry. *An Outline History of New Haven: (Interspersed with Reminiscences).* N.p.: O.A. Dorman, 1884.

Hunter-Gault, Charlayne. *In My Place.* New York: Vintage Books, 1993.

Macaluso, Laura A. *Historic Treasures of New Haven: Celebrating 375 Years of the Elm City.* Charleston, SC: The History Press, 2013.

Mather, Cotton. *Magnalia Christi Americana.* Hartford, CT: S. Andrus and Son, 1855.

Meacham, Jon. *Destiny and Power: The American Odyssey of George Herbert Walker Bush*. New York: Random House, 2016.

Mitchell, Donald G. *Report to the Commissioners on Lay-out of East Rock Park*. N.p.: L.S. Punderson, 1882.

Murphy, Hugh. *City Year Book of the City of New Haven*. New Haven, CT: City of New Haven, 1916.

Murray, Stuart. *John Trumbull: Painter of the Revolutionary War*. New York: Routledge, 2015.

Nobel Prize. "Steven Chu: Biographical." Accessed July 15, 2018. http://www.nobelprize.org/nobel_prizes/physics/laureates/1997/chu-bio.html.

Peck, Henry. *New Haven State House with Some Account of the Green: And Various Matters of Historical and…Local Interest, Gathered from Many Sources*. N.p., H. Peck & G. H. Coe, 1889, 1889.

Penobscot Marine Museum. "For Those in Peril: Rescuing Fellow Mariners." penobscotmarinemuseum.org/for-those-in-peril-rescuing-fellow-mariners.

"Poli." *Green Book Magazine* (1909).

Princeton University. "William H. Sewell '47 | Princeton Alumni Weekly." paw.princeton.edu/memorial/william-h-sewell-%E2%80%9947.

Reilly, Daniel R. "'Bring on the Dawn.'" *Navy Times* (November 1954): 14–15.

Riccio, Anthony V. *The Italian American Experience in New Haven Images and Oral Histories*. Albany: State University of New York Press, 2006.

Ryan, James Gilbert., and Leonard Schlup. *Historical Dictionary of the 1940s*. New York: Routledge, 2015.

Santoski, Teresa. "Shockingly True Tales of My Herculean, Heroic Great-Grandpa." *Tete-a-Tete*. June 5, 2014. www.teresasantoski.com/tete-a-tete-shockingly-true-tales-of-my-herculean-heroic-great-grandpa.

Seymour, Jack M. *Ships, Sailors and Samaritans: The Woman's Seamen's Friend Society of Connecticut, 1859–1976*. New Haven, CT: WSFS, 1976.

Sharp, Penelope C., Ralph S. Lewis, Ralph S., David L. Wagner and Cara Lee. "Bulletin No. 41: Trap Rock Ridges of Connecticut: Natural History and Land Use" *Bulletins* Paper 41 (2013). https://digitalcommons.conncoll.edu/cgi/viewcontent.cgi?referer=https://www.google.com/&httpsredir=1&article=1041&context=arbbulletins.

Shumway, Floyd, and Richard Hegel. *New Haven, an Illustrated History*. Woodland Hills, CA: Windsor Publications, 1987.

Smith, Jean Edward. *Bush*. New York: Simon & Schuster, 2017.

"The Story of New Haven's Municipal Airport." *Union & New Haven Trust Company Journal* (1956).

Thorp, Raymond W. *Spirit Gun of the West: the Story of Doc. W.F. Carver; Plainsman, Trapper, Buffalo Hunter, Medicine Chief of the Santee Sioux, World's Champion Marksman and Originator of the American Wild West Show*. Glendale, CA: A.H. Clark Co., 1957.

Trinity on the Green. "The Gothic Church." trinitynewhaven.org/historic-trinity/the-gothic-church.

Yale, Slavery & Abolition. "James Hillhouse." www.yaleslavery.org/Abolitionists/hillhs.html.

Newspapers

Augusta Chronicle
Chicago Tribune
Hartford Courant
Hartford Weekly Times
Long Beach Press-Telegram
New Haven Daily Morning Journal and Courier
New Haven Journal
New Haven Register
New York Times
Washington Post
Yale Courant
Yale Daily News

INDEX

INDEX

About the Authors

R obert Hubbard is a retired professor at Albertus Magnus College in New Haven, Connecticut. Kathleen Hubbard is a retired teacher from the Middletown, Connecticut, public school system. Both were born in Middletown, and each has lived in the greater New Haven area for thirty years. They are the authors of Images of America: *Middletown*, *Legendary Locals of Middletown* and *Hidden History of Middlesex County*. In addition, Robert is the author of *Armchair Reader: The Last Survivors*, Images of America: *Glastonbury, Connecticut's Deadliest Tornadoes* and *Major General Israel Putnam, Hero of the American Revolution*.

Visit us at
www.historypress.com